APERTURE

Technology and Transformation

When we transform our environment we transform ourselves. That statement is seldom contested and is perhaps self-evident. Yet the nature and exact measure of change is more difficult to assess. This issue puts forward—in pictures and text—a few potential scenarios for where we have been and where we are going. The focus is on technology because it has largely dictated the tenor and rhythm of our life in this century. These advances have also been responsible for accelerating the process by which forms—and consciousness—transmute.

From the machine age to the electronic age, the camera has been inextricably tied to technology. Still and movie cameras are the products of a mechanized society; after all, they are machines themselves. (This is no more eloquently pictured than in the gleaming gears and sprockets of Paul Strand's classic photograph *Akeley Motion Picture Camera*, 1923.) Early photographers such as Muybridge and Fox Talbot were gentlemen scientists as much as they were artists, exploring the mysteries of motion or papers that are sensitive to light. Although photographers owe a great debt to science, their response to mechanization runs to extremes: the machine has been embraced as the mechanical manifestation of man's consciousness and condemned as an interloper on the natural order.

The photographer, in describing our world, must describe the world of technology. The camera is the medium of this age; technology and the attendant transformations are its message. Dziga Vertov's seminal film *The Man with a Movie Camera*, with its futurist evocations and its language of dislocation, is as much about a mechanized society as Chaplin's more explicit *Modern Times* or Kubrick's *2001*. Although no machines are present in Lewis Baltz's *San Quentin Point*, there is a direct connection between the tools of our society and the ravaged landscape on view. The facts of postindustrial detritus are thrust violently forward, along with a vision of natural and manmade objects combined in a modern mutation. Here is where the artist affects his own transformation. Like David Hanson in his "Colstrip, Montana" series, Baltz finds beauty in the brutality, a new order in the chaos.

Throughout this issue, artists observe a world of grids, sanitized interiors, and dioramas, bringing relative degrees of recoding and self-projection to bear. On one hand, formalists such as Charles Sheeler and Robert Cumming respond to the machine as object. While these photographers assiduously explore the contours of technology, they do so with a neutrality that mirrors science's own indifferent advance. At the other extreme, Kira Perov presents a body of work that speaks more emphatically of future potentials. Her collection of video stills, along with the computer-based conjecture of Nancy Burson, demonstrate that a mastery of technology moves the artist towards a wider range of expressive possibility. These artists roll out a tapestry of new image vocabulary—one that allows for the manipulation of real life images in the pursuit of a new idea. From the camera's beginnings artists who embrace the technology have often found the best reasons for hope. This is perhaps the most potent reminder that technology has no agenda of its own. As in the constant exchange between the observer and the observed, the artist/inventor and his creation affect and append each other. In this light, Rainer Maria Rilke's words of 1904 still apply: "the future enters into us . . . in order to transform itself in us long before it happens."

THE EDITORS

*We now have sufficient historical perspective to
realize that this seemingly self-automated mechanism has,
like the old "automatic" chess player, a man
concealed in the works; and we know that the system is
not directly derived from nature as we find it on earth
or in the sky, but has features that at every point
bear the stamp of the human mind, partly rational,
partly cretinous, partly demonic.*
<div align="right">LEWIS MUMFORD, *The Myth of the Machine*, 1964</div>

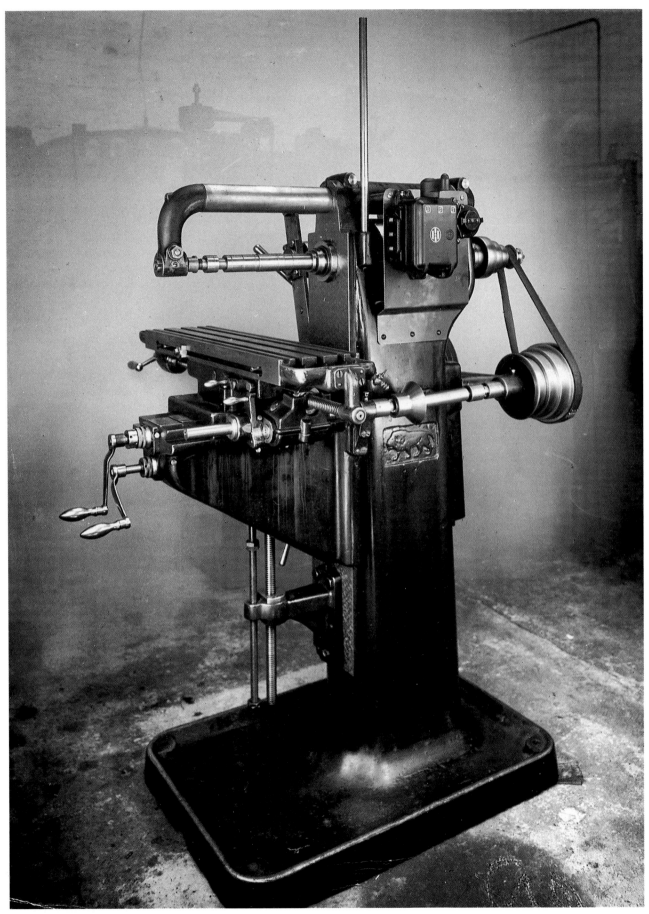

AUGUST SANDER, c. 1930

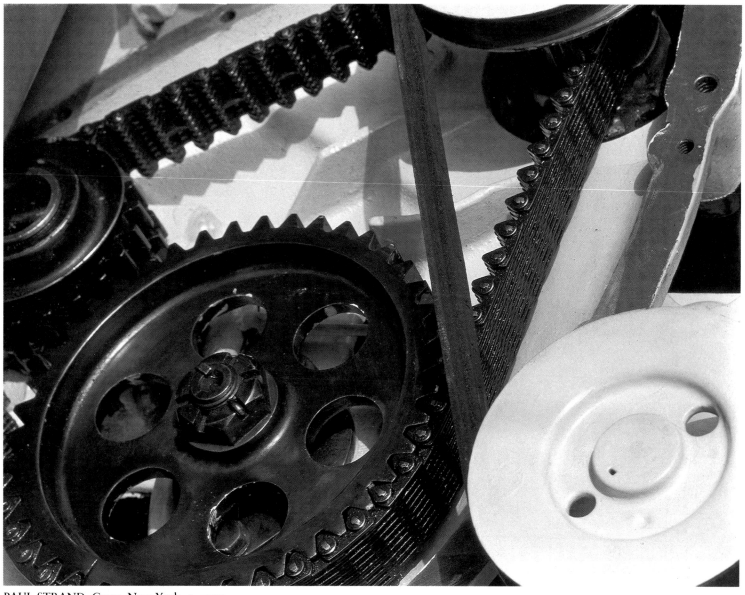

PAUL STRAND, Gears, New York, c. 1920

*Out of wood and metals [the scientist and inventor] made hands that could do the
work of a thousand men: he made backs that could carry the burden of a thousand beasts and
chained the power which was in the earth and waters to make them work. Through him,
men consummated a new creative act, a new Trinity: God the Machine, Materialistic
Empiricism the Son, and Science the Holy Ghost.*

PAUL STRAND, *Photography and the New God*, 1922

JANOSLAV RÖSSLER, 1934

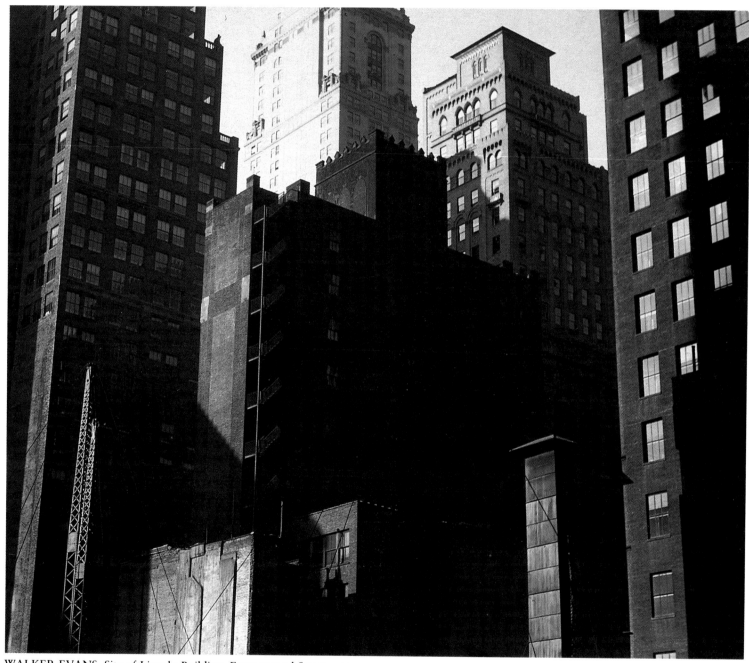

WALKER EVANS, Site of Lincoln Building, Forty-second Street, 1930

I was to find forms which looked right because they had been designed with their eventual utility in view and in the successful fulfillment of their purpose it was inevitable that beauty should be attained. CHARLES SHEELER, 1932

CHARLES SHEELER, Upper Deck, 1928

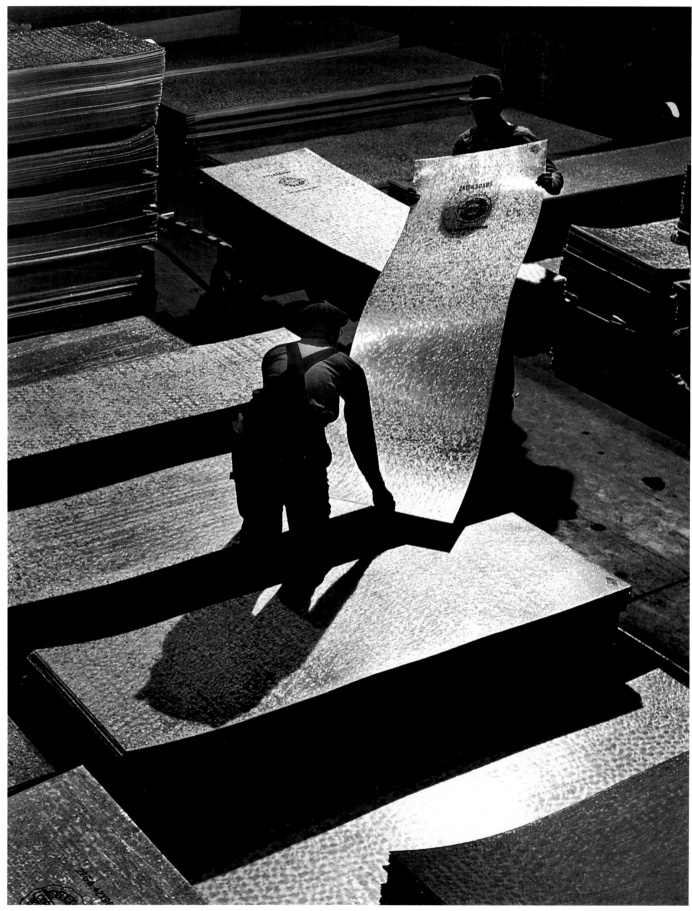

FRED G. KORTH, Galvanized Sheets, c. 1928

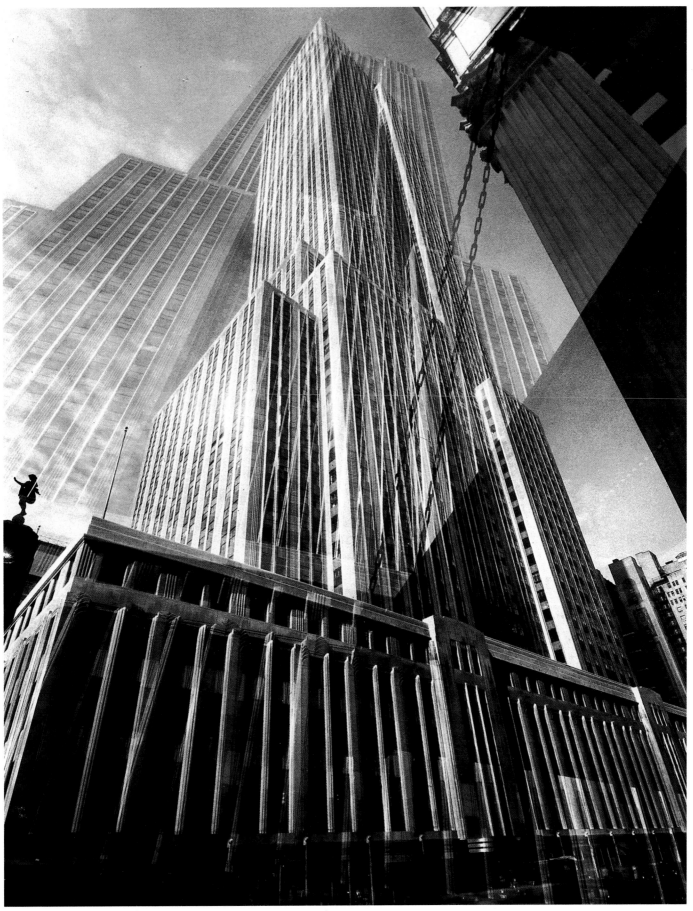

EDWARD STEICHEN, Empire State Building, 1932

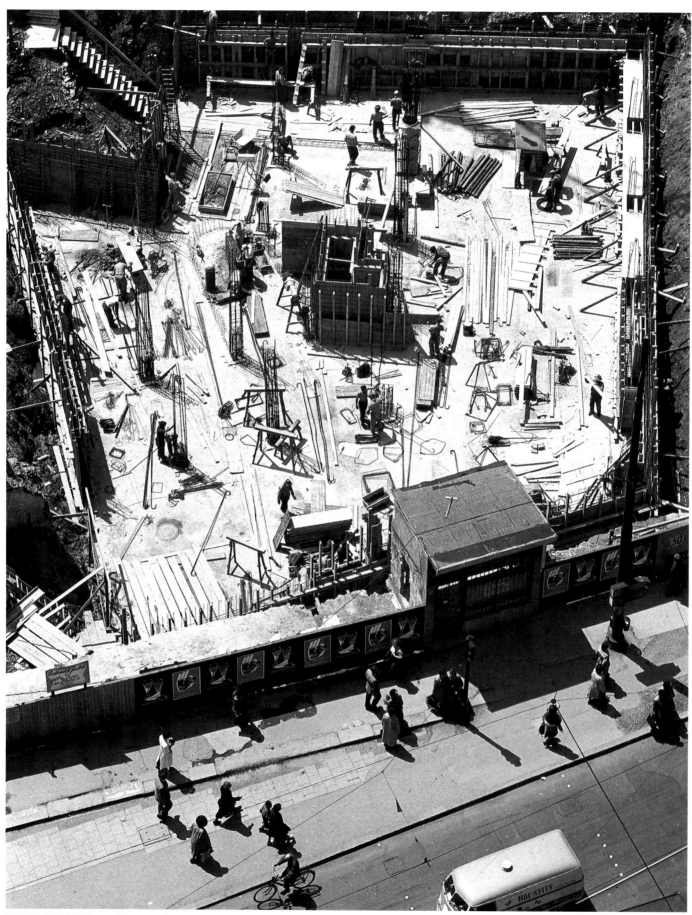

PETER KEETMAN, Plastic Profiles, 1963

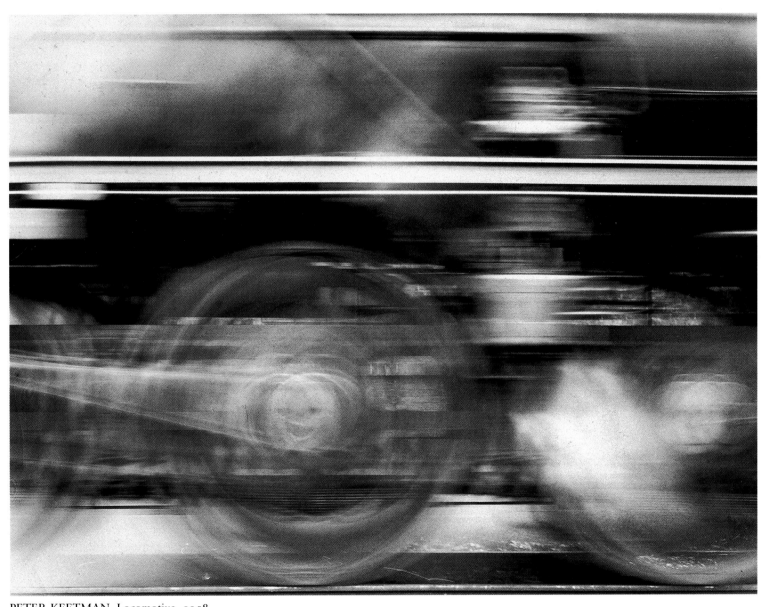

PETER KEETMAN, Locomotive, 1958

. . . man is never happy except when he becomes the channel for the distribution of mechanical forces.

<div align="right">EVELYN WAUGH, Decline and Fall, 1956</div>

Lewis Baltz: San Quentin Point

By Mark Haworth-Booth

San Quentin Point, by Lewis Baltz, is akin to a magnetic field. The photographs, considered as a totality, reorder several trains of thought, adjust a number of elements of photographic history, provoke redefinitions of the medium in which they were made, and—to this reader/viewer—possess an unusually acute personal resonance. Like all substantial works of art, *San Quentin Point* realigns surrounding phenomena and establishes a new symbolic landscape.

San Quentin Point was photographed in 1982–83 and occupies a special position in the evolution of Baltz's work. The American photographic tradition relevant to Baltz is intricate but well defined. In 1915 Charles Sheeler photographed *Bucks County Barn* flat on, close up, in detail and with artistry. His example as a modernist in photography and painting was influential in the following decades. Walker Evans in the 1930s photographed small-town façades with a similar plain spoken subtlety. More crucially for Baltz, Frederick Sommer brought to American photography important ingredients of European Surrealism, which he fused with a technique learned from Edward Weston. Sommer's Arizona landscapes were published in *VVV,* the magazine of New York Surrealism, at the insistence of Max Ernst in 1944. These photographs proposed that the desert landscape was not a setting for anthropomorphic display but a site indifferent to human concerns, and almost lunar in aspect. Sommer also introduced into American photography an iconography of the disregarded—or "unphotographable"—such as visceral organic details and industrial detritus. Baltz's later concerns seem to be accurately indicated by Sommer's view of the photograph: not as a "moment of truth, but as truth before the fact." The importance of Sommer in relation to the photographers associated by the term "New Topographics" is stated with clarity by Jonathan Green in *American Photography: A Critical History 1945 to the Present* (1984). Lewis Baltz has illuminated, by his practice, some of his distinguished elder colleague's most inaccessible work. Balt'z first book, *The New Industrial Parks near Irvine* (1975), is a foundation block of New Topographics ideology. It is informed by detachment, irony, and allusiveness. On his subjects the photographer superimposed visual ideas drawn from Minimal art. The underlying theme of this series is the proposition not only that buildings such as garages or high-tech workshops resemble works of art but that the constructions of the socioeconomic order are precisely that: the world, like it or not, as "installation," asking what is installed, by whom and how. *Nevada* (1978) records New West urbanization. Here the theme includes a set of contrasts featuring artificial and natural light, the latter presented as ebbing into twilight.

Park City (1980) is a series of 102 photographs that describe the construction of the ski resort of this name a few miles east of Salt Lake City. Bearing on the extensive nature of this project is Baltz's long-standing awareness of the dubious veracity of the single photograph. In his text for *Park City,* Gus Blaisdell coined the phrase and developed the notion of "Landscape-as-Real-Estate." Baltz's photographs of Park City reflect his opinion that such places are most interesting, or revealing of themselves, when their construction is incomplete. Part of his point may be that even when finished these places are, from a certain point of view, intrinsically unfinished. If this is correct, Baltz's position chimes accurately with that of Joan Didion in her essay "Many Mansions" (1977), reprinted in *The White Album* (1979). Didion reflects on the specific qualities and symbolic properties of "the new official residence for governors of California, unlandscaped, unfurnished, and unoccupied since the construction stopped in 1975." The implications of this eloquent shell lead her to conclude: "I have seldom seen a house so evocative of the unspeakable." Similarly, the notion of the building plot as site of mythic identity, and its use as a central metaphor, is found not only in *Park City* but in the Wim Wenders/Sam Shepard film *Paris, Texas.* There a color snapshot of a barren plot provokes a child's question to his father: "Why would you want to buy a vacant lot in Paris, Texas?" The reply: "I forgot." Baltz was to turn next to a typical landscape of forgotten things.

San Quentin Point, photographed four and five years after *Park City* began, is an example of the genre Lewis Baltz has evolved, which we might call the oblique epic, even if that is a contradiction in terms. I first saw the *San Quentin Point* photographs in the form of a slide presentation Baltz gave at an international gathering in Graz, Austria, in the autumn of 1982. The experience emphasized two points: First, that these photographs occupy an ambiguous position in terms of scale. Given the camouflage afforded by context, some photographs in the series could easily pass as either photoelectron-microscope enlargements or reductions of enormous extraterrestrial images: say, the surface of an albumen print in extra close-up, or the Badlands from space. Second, an international audience found a great deal to look at in these photographs. I recall that Baltz remarked on that occasion that "it is probably not necessary to know this, but San Quentin Point is adjacent to the most notoriously affluent and bourgeois suburban county in California." Apparently the equally notorious prison at San Quentin withheld the speculating arm for many years, but at last luxury apartment houses, boutiques, and parking lots prevailed. "I was curious to see if I could photograph near where I live," Baltz continued. At the time I found this remark surprising. I now find it revealing. The audience in Graz was able first to perceive *San Quentin Point* in international aesthetic terms and then to

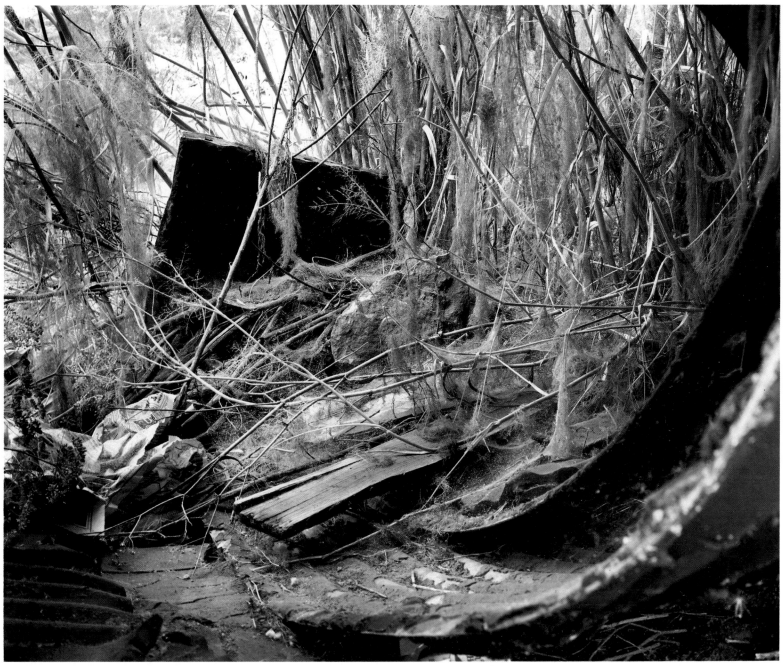

LEWIS BALTZ, from *San Quentin Point*, 1982

respond to its subject as a common property. The "Waste Land" at San Quentin Point touched a nerve. The work evoked a complex iconography of the late twentieth century and simultaneously aroused a private psychological fascination.

I have in front of me my immediate impressions of *San Quentin Point*:

We saw pictures of the rank vegetation characteristic of bombsites and railyards. Bedsprings or whatnot, cloth pressed into the earth as if steam-ironed, thistles spraying up regardless, nameless slimy things, rendered with the exquisiteness with which any trash can, quoth Walter Benjamin in

days of yore, could and would be beautified by photography. . . . As honesty, a dilapidated, beautiful and plentiful plant . . . flourishes especially beside English motorways, sturdy common things glinted among the bits of broken glass . . . at San Quentin Point. they gained stature as they multiplied. . . .[1]

Later I heard someone asking about the role of the photographer, and Baltz spoke of how a photographer could, maybe, roam the world assigning values: "But this robs the viewer of participation in the work. It robs viewers of the responsibility they must have." Working in sequences, sometimes extensive

ones, is a way of setting up a field or screen on which the viewer can project some hitherto invisible messages more or less in private as well as at some length.

San Quentin Point strikes a contemporary note because the photographs seem to be the work of someone who, like his audience, lives in a world familiar with an extraterrestrial perspective on itself. They are part of a peculiarly modern visual field. Baltz's use of the camera is also part of the sensibility of this time. For some years I have been intrigued by the fact that the modern detective emerges in the same decades as the professional photographer. The fascination is compounded by the participation of the major English-language novelist of that period, Charles Dickens, in the formulation of the fictional detective. Dickens conferred on his Inspector Bucket in *Bleak House* a kind of functional or forensic vision that is actually, like his own vision and literary style, highly photographic. Photography has always had forensic objectivity as one of its main options. The characteristc photographs of Diane Arbus and Garry Winogrand accept and accentuate the forensic capability of the medium. They present phenomena untrammeled by emotion or empathy. This forensic stance is characteristic of Balt'z method. Part of the iconography of this kind of photography is to be found in Walter Benjamin's famous statement:

Not for nothing have Atget's photographs been likened to those of the scene of a crime. But is not every square inch of our cities the scene of a crime? Every passerby a culprit? Is it not the task of the photographer—descendant of the augurs and haruspices—to reveal guilt and point out the guilty in his pictures?

Perhaps San Quentin Point has—as mediated by these photographs—become an arena where such a social investigation can be enacted. The photographs follow, I believe, the tendency of Benjamin's illuminating remarks. Nearer at hand these photographs are also made yet more transparent by two remarks from the great cinematographer Nestor Almendros. He comments first on photography as transformation: "Through the lens, something like an automatic transfiguration is produced on the photographic emulsion. Everything seems more interesting on film than in life." Second, on the frame: "By means of the camera's viewfinder, the outside world goes through a process of selection and organization. Things become pertinent; thanks to the parameters of the frame, they take shape in relation to vertical and horizontal limits. We know at once what is good and what is bad. Like the microscope, the frame is an analysing tool."[2]

These remarks help to account for the most unexpected fascination of *San Quentin Point*. Baltz has, in the guise of a forensically neutral statement, actually beautified the phenomena of an urban wasteland. Second, by using the frame as a microscope he has suggested that the disturbances observed here in miniature are legible as part of a larger allegory. He observes a set of violations in a microcosm, and for me the photographs resonate with an irony reminiscent of the manner in which the behavior of Lilliputians was chronicled by Jonathan Swift.

Baltz has recently imposed a degree of finality on his work of the past dozen years. He regards *San Quentin Point* as the third and final portion of a trilogy that began with *The New Industrial Parks Near Irvine, California* and continued with *Park City*. (In this scheme of things, he places the notable series on Nevada in a perhaps unnecessarily modest position as "experiment"). The idea of the trilogy changes the way we might read each of the three parts that make up the larger whole. Clearly there is a progression—or should we say merely an alteration?—from the almost dapper formal specimens scrutinized in *The New Industrial Parks Near Irvine, California* to the theater of order and chaos assembled in *Park City*. In *San Quentin Point* it appears that chaos has claimed victory to the point where even the notion of "victory"—by what and over whom?—is displaced from the usual map of meanings. The photographs seem to utter only a sharp entropic decline, and the final images resemble very little at all anything that one can make sense of.

That is one view of the trilogy. There is another possibility. In Baltz's opinion some photographs in *San Quentin Point* are as highly ordered as—or even more highly ordered than—the first images in *The New Industrial Parks Near Irvine, California*. How can this be? The analogy is with that kind of anarchy that is not chaos but rather a form of nonhierarchical social organization so complexly ordered as to defy the sort of analysis useful in describing dictatorships, democracies, and so on. That metaphor has the virtue of inviting the visitor to circle the contents of *San Quentin Point*, and each image in it, with a new sense of what order might be and how the evidence for it might be found.

Finally, it seems that the waste ground of *San Quentin Point* is part of the natural adoptive territory of puberty and early adolescence—a disregarded tract littered with fragments and oddments of the adult world, with the exception of adults themselves. Here parts of the made world are found in mysterious bits, unmanufactured by time and use. Animal, vegetable, and mineral phenomena form strange and unintentional constellations. At a certain age many children wander among the luxuriant thickets of such places. They engender a surprising intensity of recall. It is unlikely that anyone could be sentimental about such places—or ever quite unlock their hold on a distant stratum of the imagination. It is surprising and even somewhat shocking to find such a primal and ambiguous world exposed in these photographs. It is an experience we may feel more likely to encounter in a novel or a film but have been taught by some few photographers to find elsewhere.

1. These notes form part of my essay "A Letter from Graz," published in *Aperture* No. 90 (1983). Lewis Baltz's text from Graz is published in *Camera-Austria* No. 11/12 (1983).
2. Nestor Almendros, *A Man with a Camera*, London, 1985, pp. 10, 12–13.

Catherine Wagner: The Louisiana World Exposition

By Larry Frascella

Catherine Wagner is an omniscient narrator; her work is characterized by its clearheadedness and what has been called her "neutral noneditorial stance." These qualities served her well when she was commissioned by the Canadian Center for Architecture to record the construction of the 1984 Louisiana Exposition in New Orleans. Standing back from this epic endeavor, she captured its megalithic proportions and, by coolly following the development of the structures, she allows a sense of time to pass through these images, saving them from the need to be single, static summations or a series of crystallized sentiments. This sense of passing time lends weight to the work as a microcosm, a metaphor perhaps for any industrial city rising out of the asphalt to touch the sky.

Geometry—the understructure of architecture and of so much contemporary form—is largely the subject here. (Even in completion, these palaces and pavilions wear only the thinnest skin.) Wagner concentrates on the skeletons that support our technological wares: those speeding, buzzing, eye-opening three-dimensional advertisements for civilization that are the mainstay of a world's fair. New modes of transportation and forms of entertainment—new tools and new visions—are presented, all in the name of progress and its promise of great tomorrows. As stated in The CCA's introductory text to Wagner's portfolio:

> *Beginning with the great exhibition of 1851 in London, World's Fairs have used the idiom of architectural fantasy to celebrate the achievements of an industrialized world. Within a few acres, each country has erected a pavilion, often adopting indigenous architectural styles, to display commercial and cultural achievements. As a result each site has had the appearance of a museum and scientific display within an amusement park. The Louisiana World Exposition of 1984 was no exception.*

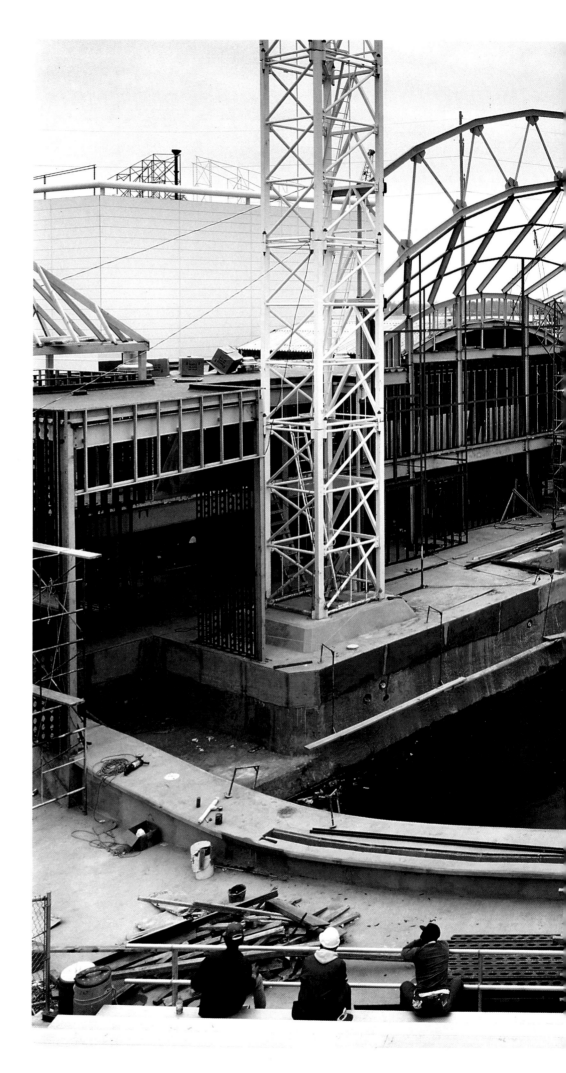

CATHERINE WAGNER,
Aquacade Construction, 1984

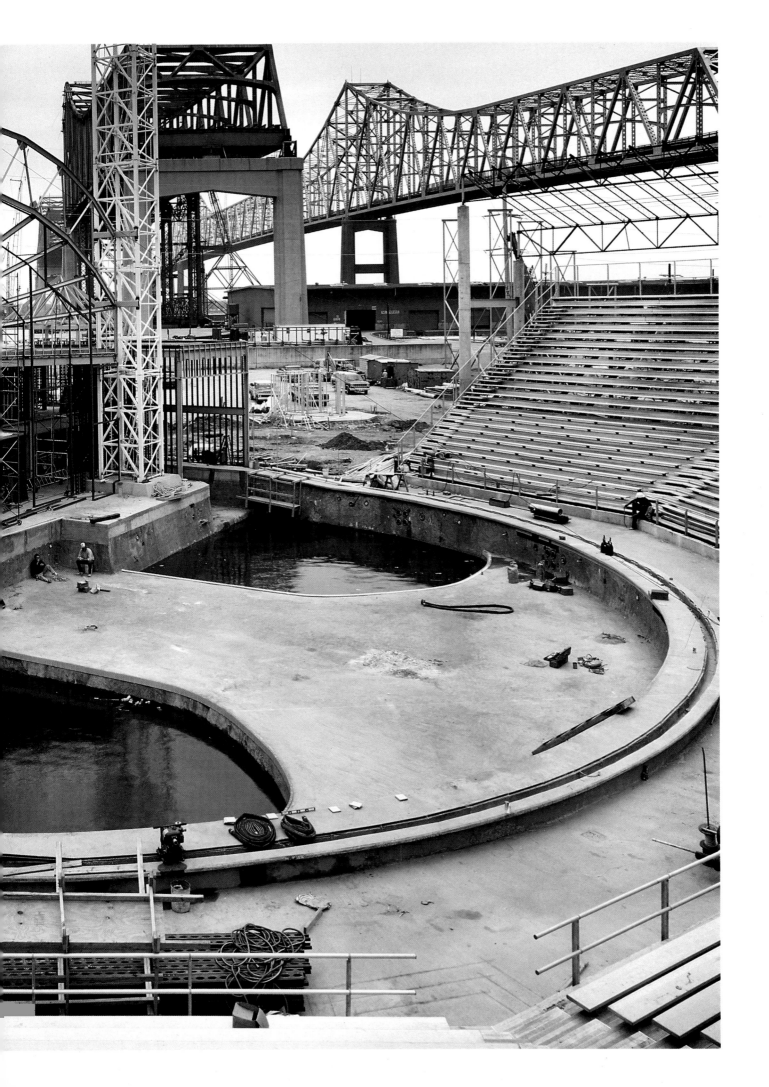

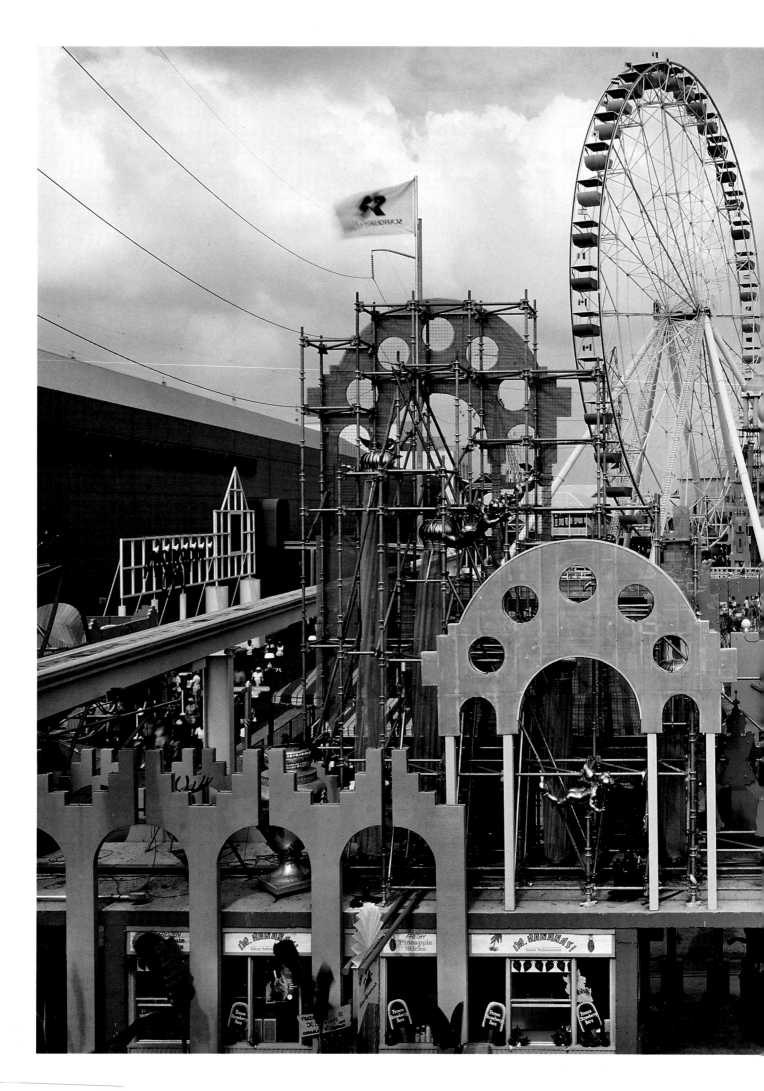

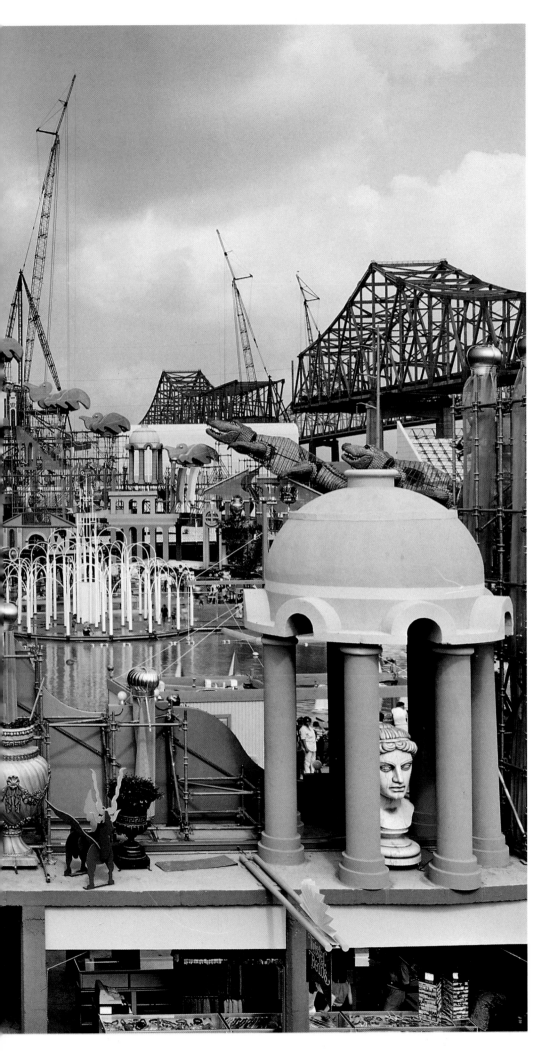

CATHERINE WAGNER,
Vista from Monorail
of Wonderwall, 1984

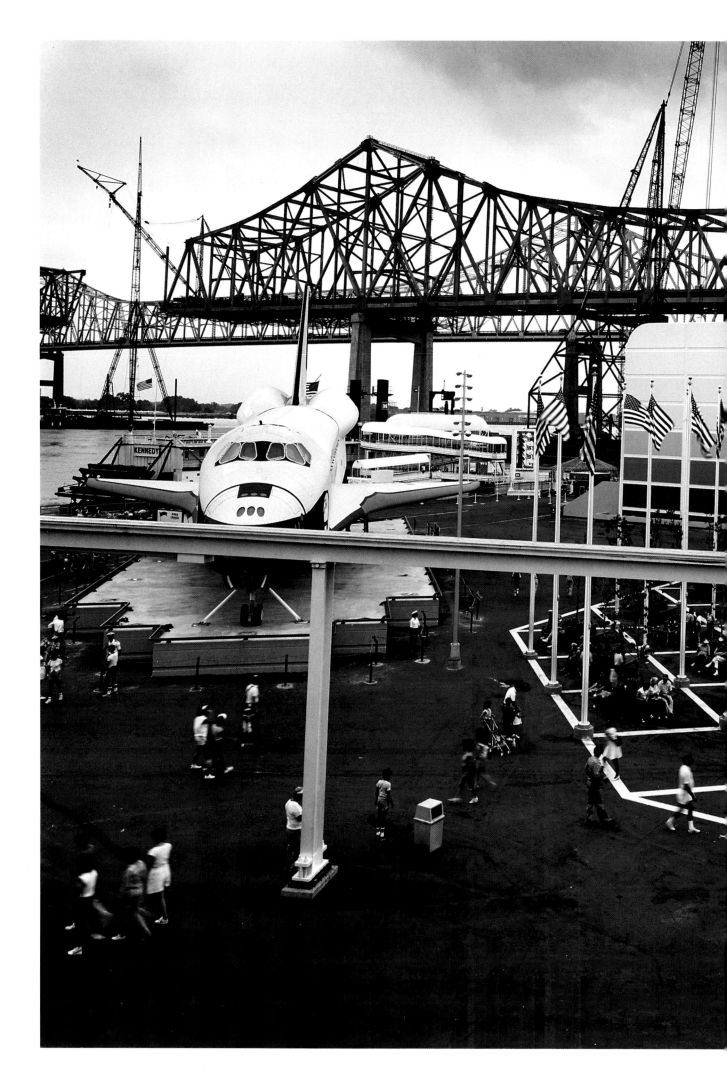

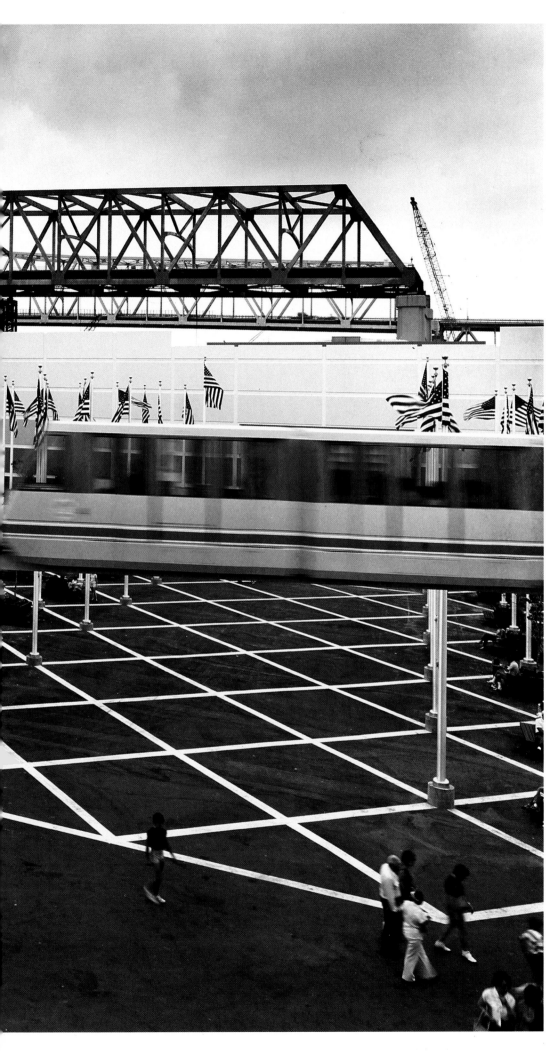

CATHERINE WAGNER,
Spaceship Enterprise Along
the Mississippi River, 1984

Lynne Cohen: Room Readings

By William Ewing

Not long ago I had an opportunity to visit the aircraft carrier USS *America*, moored discreetly just over the horizon off the Lido in Venice. I was staggered by the immensity of this floating fortress, several football fields (always the proud all-American yardstick!) in length, the bristling armaments and electronic eyes and ears, the fleet of sleek aircraft. With its twenty-seven deck levels, its banks of high-speed elevators, and its softly lit corridors stretching seemingly to infinity, the ship resembled a corporate headquarters in New York. In quintessential executive style, a legal adviser's office lay behind a floor-to-ceiling wall of curtained glass. But, however incongruous this seemed on a fighting ship, the real surprise was the seamen's lounge: here was a fantasy that may best be described as simulated homestead, filled with "coach" lamps, "wood" paneling, and "colonial" furniture. It struck me that solace in an imagined past would compel future stations in space to look like this—far from the cool, functional interiors prophesied in Kubrick's *2001*. I recalled McLuhan's observation that we always drive into the future looking into the rear-view mirror. And I thought of Lynne Cohen, who would relish these anomalies.

Cohen has always had a loyal following, but in very recent years she has found a wider circle of admirers. Unlike the work of many other photographers who emerged in the 1970s, hers does not seem dated in ideas, formal concerns, or style but has managed to maintain its vigor and topicality. Stylistically, Cohen's pictures have been remarkably consistent over fifteen years. Still, there have been shifts; the obvious ironies of the kitsch-imbued spaces of her early years have given way to far subtler messages conveyed by far more unsettling environments. In the disturbed 1980s, Cohen's warnings are no longer falling on deaf ears.

With few exceptions, Cohen's work comprises interiors made with large-format cameras and—always—available light. The prints are finely rendered, not in blind obeisance to the cult of the fine print but in order to record information with great precision. Although the interiors themselves can readily be thought of in terms of their function—living rooms, ballrooms, lobbies, offices—they can also be grouped according to far more telling and provocative criteria relating to concepts of nature and of social class and other hierarchies, authorities, or mechanisms for behavioral manipulation. With such schemes we might better understand Cohen's current obsession with observation rooms, social laboratories, and shooting galleries; in her mind, such interiors speak of insidious social engineering.

As unlikely as it seems, Cohen has never manipulated the interiors in any way. She has come to expect incredulity as an initial response to her work, and for herself, often to be mistaken for an installation artist. But though she never imposes order on the rooms themselves, she certainly fashions a pictorial order, which comes from the confidence and control born of experience. Carefully considered are: camera placement; the angle of view; framing; the properties of the view camera itself and choice of lens (the field is in perfect focus, and space is flattened so that details such as light switches and sockets, which are normally considered insignificant, are given the same weight as culturally revered objects); and how materials, surfaces, and textures will be rendered on photographic paper.

On the question of order, consider the prevalence of symmetry in these rooms. The balanced arrangements denote hierarchical relationships and imbue certain functions of a room with authority. Even if those who set up such environments are not conscious of this symbolic content, they are nevertheless trying to control the visitor's behavior. But it is important to realize that Cohen works with and in fact reinforces the symmetries (by careful framing that ignores other qualities of the rooms). By doing so she directs our awareness toward these cultural and psychological assumptions. Because we are not used to reading rooms in this manner, they appear unusual and exotic.

People do not appear in Lynne Cohen photographs. She wishes each *room* to be the subject; if people were included, the room would be relegated to background information. But if real people never appear, idealized representations often do. They show us how to dress, move, and interact—that is, how to function as types rather than individuals. Cohen mocks our society of sham individualism.

Cohen's pictures bear many messages. In the observation room, the experimenters have set their one-way windows and their cameras high above the children in an unwitting admission of dominance. In the air- and space-conditioned offices, modernism has gone awry. (Note Cohen's witty handling of the floor on the right, which evokes Renaissance religious painting. But it's not the painting that is the object of her parody; it's this spiritually vacuous temple of modern man.)

For such reasons Cohen's photographs are worthy of scrutiny. Often what animates an image is a seemingly insignificant detail, such as the loose strings of the tennis net, the only relief from the taut, suffocating geometries.

In the jet trainer, a mechanical bird feeds on a black box of electronic food—simulated experience, sham reality: as idealized and standardized as the figures that adorn Cohen's walls. Perhaps the time has come to update Ruskin's notion of the pathetic fallacy.

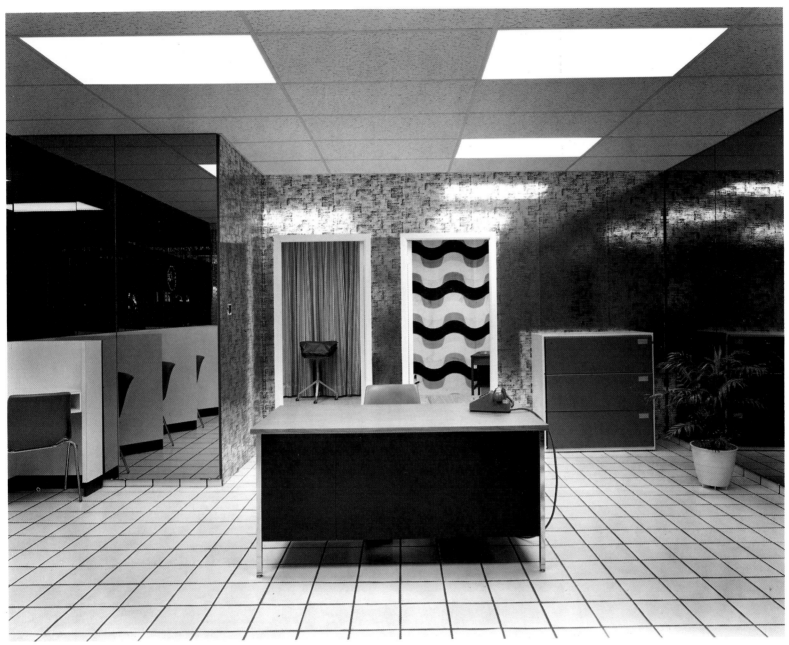

LYNNE COHEN, Employment Office For Women

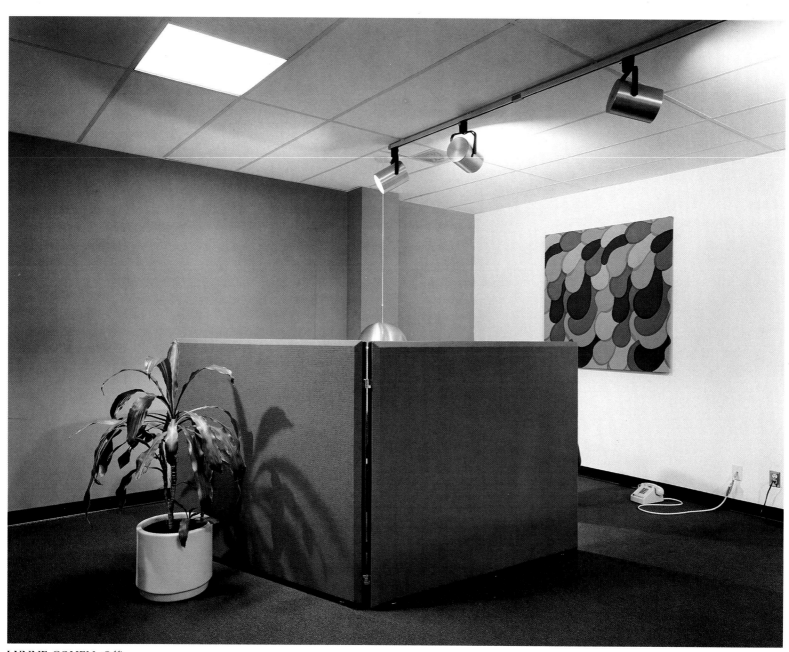

LYNNE COHEN, Office

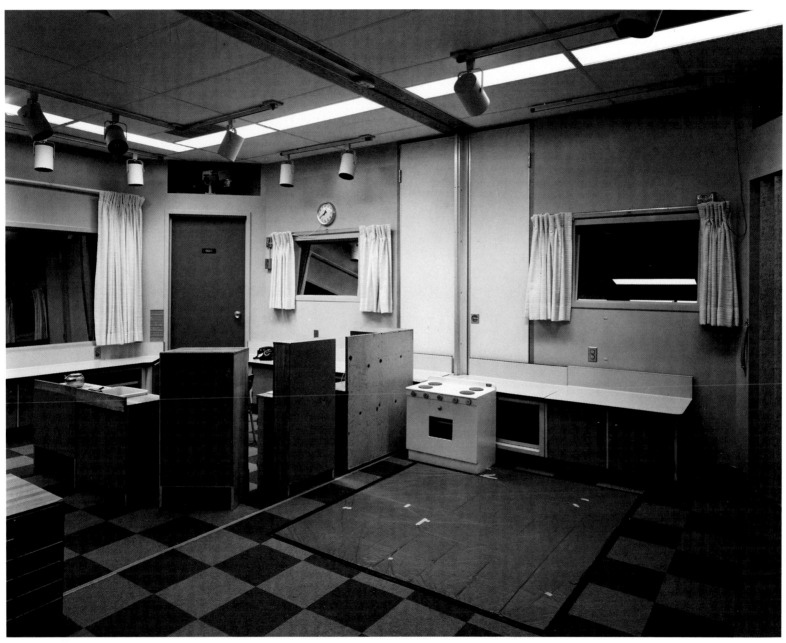

LYNNE COHEN, Observation Room

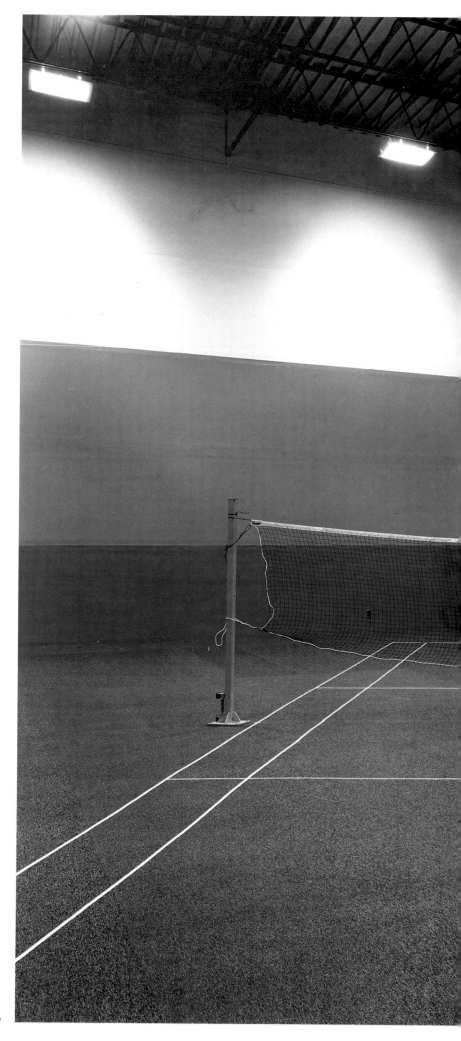

LYNNE COHEN, Racquet Club

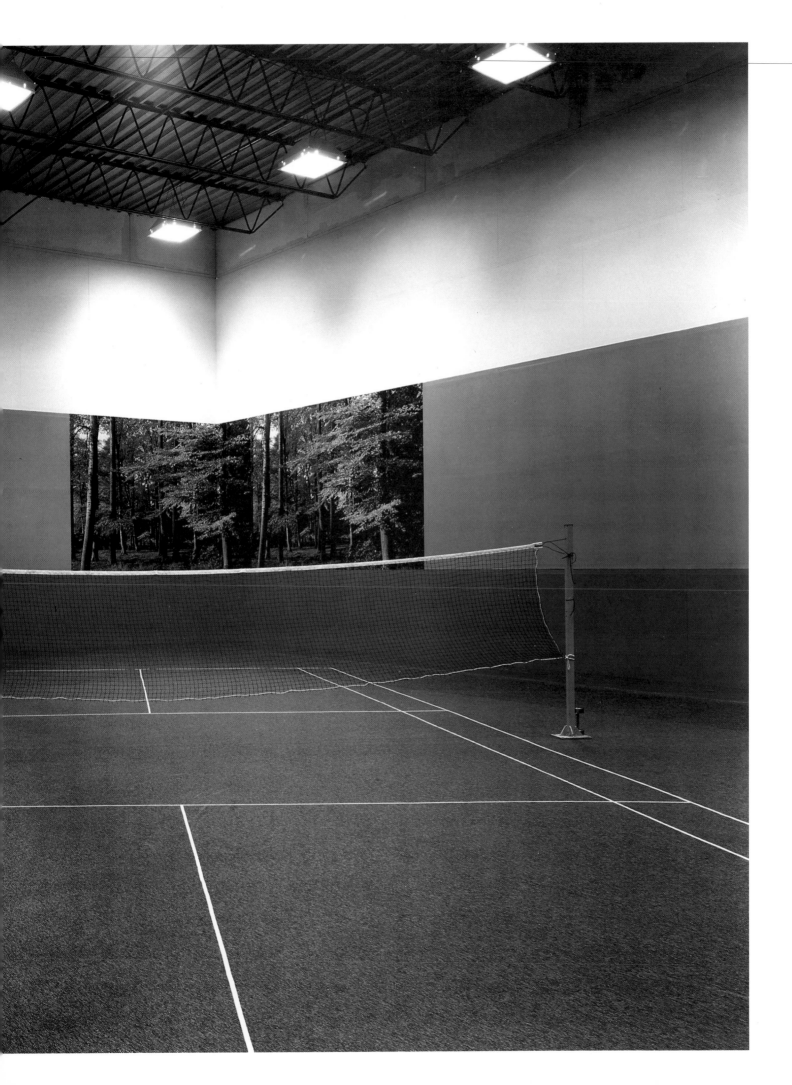

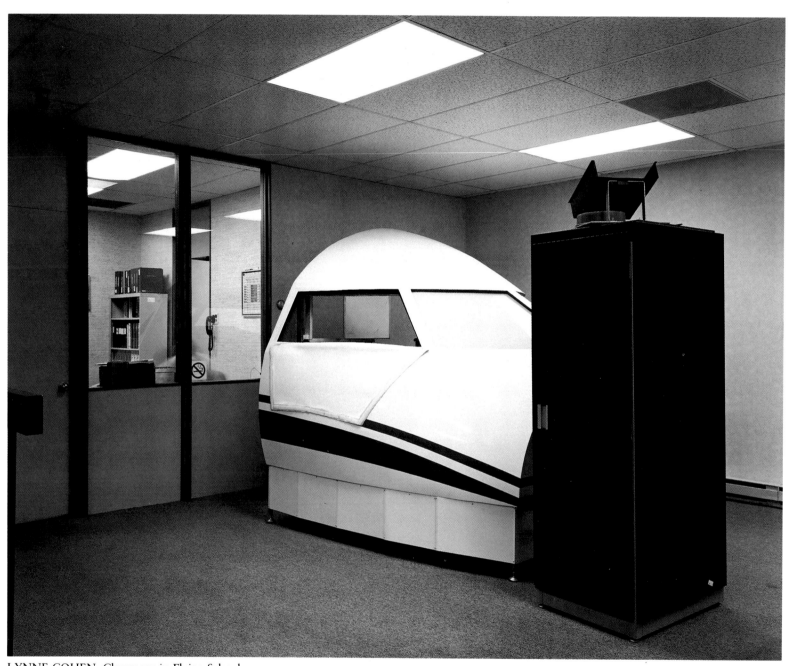

LYNNE COHEN, Classroom in Flying School

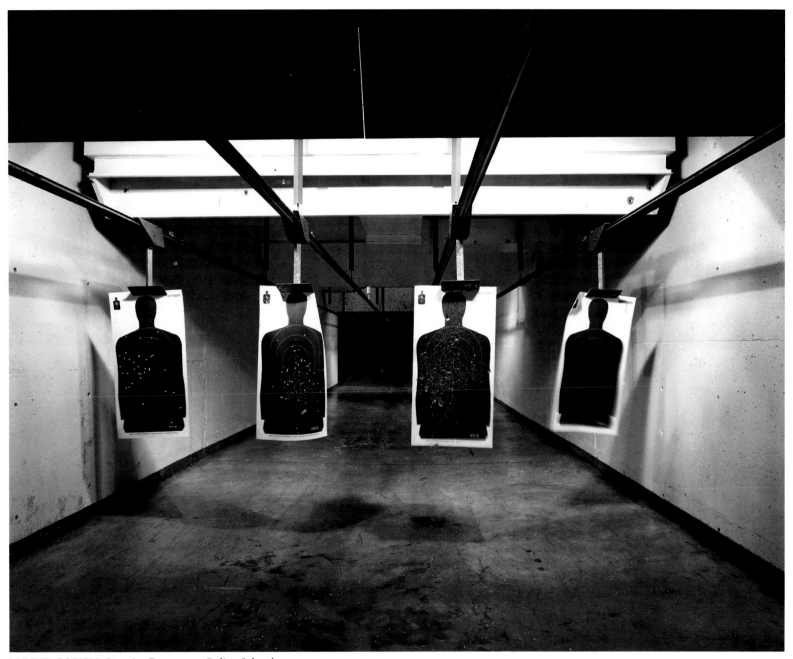

LYNNE COHEN, Practice Range at a Police School

The Reality-Museum of Daniel Faust

By Dan Cameron

Somewhere, at the terminus point of an artist's life of work and contemplation, waits the Museum, impassive and perfect. Within its massive walls and long corridors the storms of past controversy are forever quelled; History, the Museum's handmaiden, has long since separated its wheat from the chaff, delegating all artists and artworks to their respective niche (or lack thereof) in the panoply of artistic heritage. To conceive of the Museum in more relativistic terms—as, say, a flexible institution of social mores that addresses its constituents with an ambient flow of objects and information—is to provoke the artist's deepest fears regarding the ultimate fate of high art in a world already fraught with uncertainty. The Museum must be, above all, a *lasting* record of one special primate's odyssey through the world.

Such a highly charged definition of "museum" does not correspond to the average person's experience. For many smaller communities in America, the local museum is an educational tool, based on the model of public education introduced during the mid-nineteenth century as a means of preserving regional history, local heirlooms, occasional relics of the early Modern Age, and perhaps a painting or two. Beginning in the mid-1960s, corporate surplus and expansion of suburban populations led to the creation of a quite different kind of museum. Museums of technology, science, or natural history; "Museums of Man" and wax museums; theme parks, "interactive" children's museums, and world's fairs—these general-interest facilities reveal to what extent the postwar art museum has been relieved of its educational duties and replaced by a multiscale simulated environment that in turn projects Information Age effluvia flavored with the community pride of its nineteenth-century forebears.

Since 1980, Daniel Faust has visited "reality" museums throughout the United States, Canada, Great Britain, Western Europe, and Japan. While Faust's itinerary from one perspective resembles the idealized family vacation, it also recalls the investigative tasks introduced into the art vocabulary by pioneer Conceptual artists like Vito Acconci, John Baldessari, Dan Graham, Douglas Huebler, and William Wegman. The use of photographic documentation in this work comes to contemporary sensibilities thanks to the successful extension of these ideas in the 1980s by artists such as Sarah Charlesworth, Louise Lawler, Richard Prince, Sherrie Levine, and Cindy Sherman. Unlike that of the better-known "deconstructive" photographers, Daniel Faust's work intentionally throws back to its Conceptual roots through its conscious resemblance to the family snapshot and through the low-tech appeal that the artist is trying to maintain.

Viewed as a single body of work, Faust's photographs begin to describe a composite "Museum" whose very existence is antithetical to the practice of art. Some exhibits are tacky or unconvincing, while others binge on high-gloss spectacle. People are present only as inanimate representations, though they are continuously referred to as the absent participants in the cycles of creation and adaptation that this "Museum" monumentalizes. Evolution, war, scientific progress, and popular culture all become offshoots of the abstract entity, Man, to whose destiny and comfort all this apparatus has been dedicated. In Faust's "Museum" an equality seems to exist between the impersonal façades of complex machines and the pathetic likenesses of TV celebrities assuming stereotypical poses. Each detail has a similar role to play in the panorama of codified signs that unite all of these museums into one "Museum." The artist's camera flash plays a similar role, for it normalizes the situation of the spectator, causing us to feel that we are gazing at the scrapbook of a willing participant in the rite of high-tech acculturization.

Faust's "Museum" is also of great interest because of the parallels that can be drawn between the false image and the presumably real one, between the "Museum" of Faust and the Museum of Art. While the primary center of attention in the Museum is the unique object in which the flow of culture has somehow been summarized, it is not difficult to see other processes at work. There are, first, the artists themselves, whose individuality and expressive genius the objects represent. Then the collectors, whose private accumulations of art holdings are funneled into public institutions as symbols of their civic goodwill. The critics, curators, and historians, whose role it is to debate the relative issues of aesthetic quality and historical significance, are a third but crucial element to this process. This subtext of the Museum, apparently denied by the purity of its rooms and displays, is visible to the trained eye in exactly the way that ideology is visible to the trained observer of the "reality" museum, or of Faust's photographs. That these photographs may eventually be dispersed throughout Museums of Art suggests that Faust wishes to appropriate the museum context to show how his "Museum" operates— as a contradiction of and as an odd parallel to the process by which art becomes Art.

The role of the artist that emerges from these considerations is that of the infiltrator, or even the double agent. With his flash camera at the ready, Faust passes for the average tourist—he is even frequently approached by helpful dads who explain to

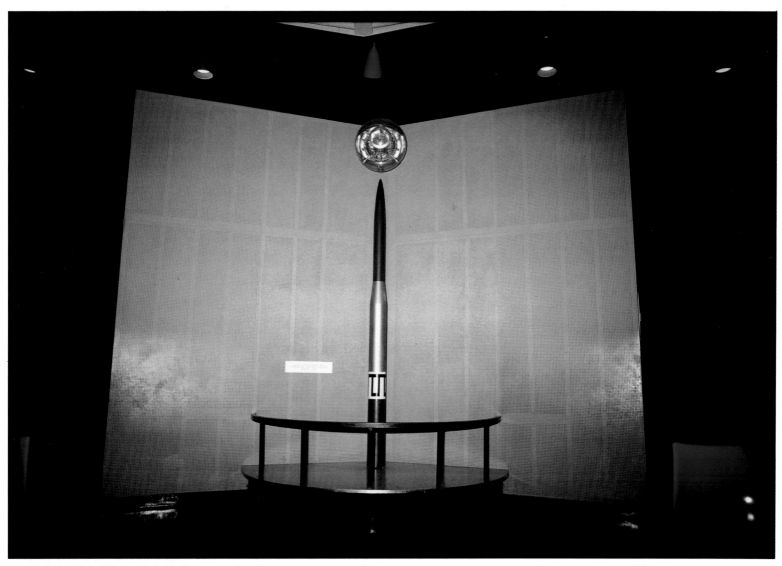

DANIEL FAUST, "Monument," Chicago, 1983

him that his pictures are not going to come out right. The photos that Faust brings back from these expeditions are also, on the face of it, quite normal, especially in the sense that they are not "right." That normality be equated with the absence of standards is one of the central concerns of Faust's work. Still more important, perhaps, is the way these images infiltrate museums as artworks, because their normality is in fact a refutation of the hierarchy of greatness that the Museum represents. Unlike the imaginary Museum in which every artist would like his or her work preserved for eternity, Faust's "museum" catches us in the act of promoting our collective self-importance through culture. How more appropriate than through this systematic reversal of values, in which we gaze at Western civilization preening vainly as it displays a few of its less flattering aspects to a swarm of true believers?

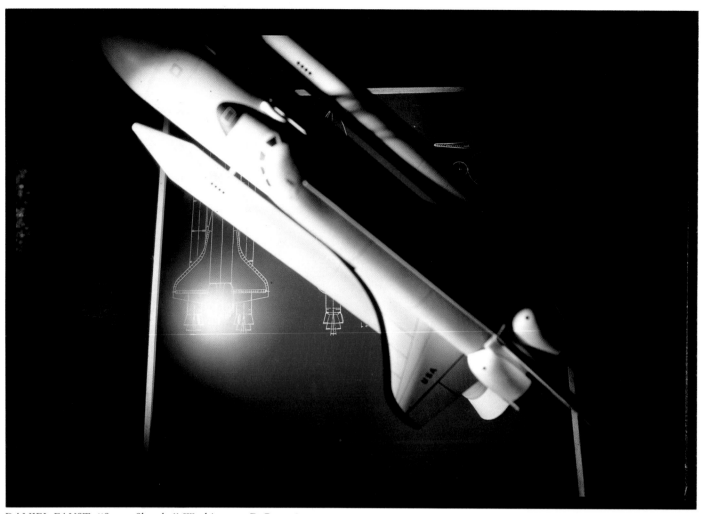

DANIEL FAUST, "Space Shuttle," Washington, D.C., 1984

DANIEL FAUST, "Space Satellite," Vienna, 1984

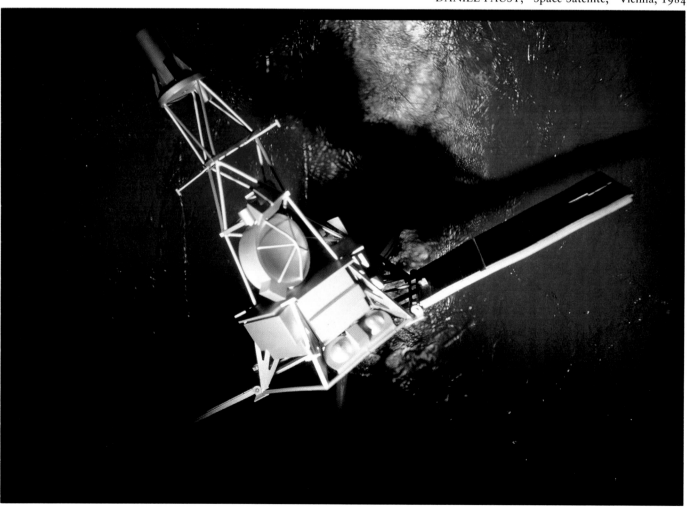

DANIEL FAUST, "Exploration," London, 1984

DANIEL FAUST, "Eject," Switzerland, 1984

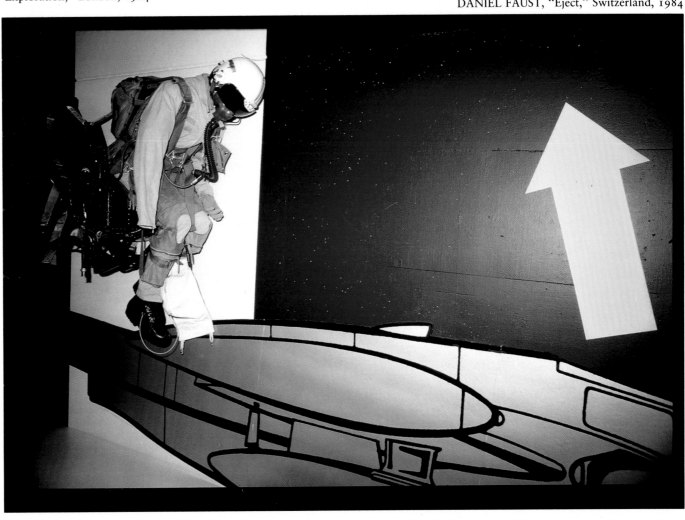

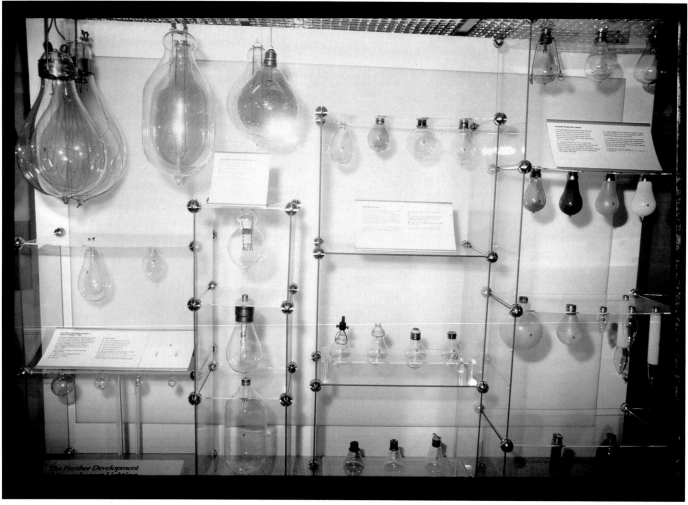

DANIEL FAUST, "History of the Incandescent Light Bulb," London, 1984

DANIEL FAUST, "An All-American Product," Chicago, 1983

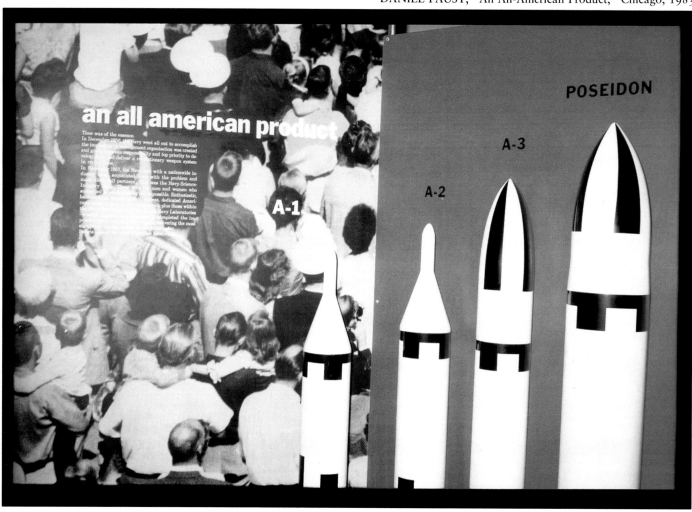

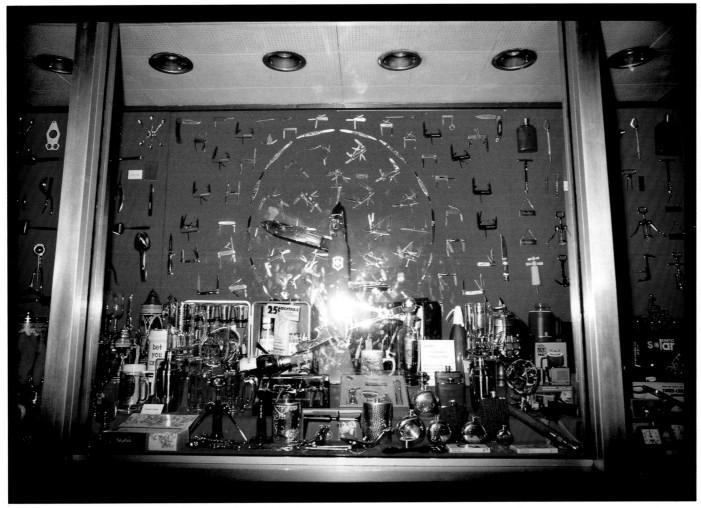

DANIEL FAUST, "Hoffritz Window," New York, N.Y., 1984

DANIEL FAUST, "Capital Goods," Chicago, 1983

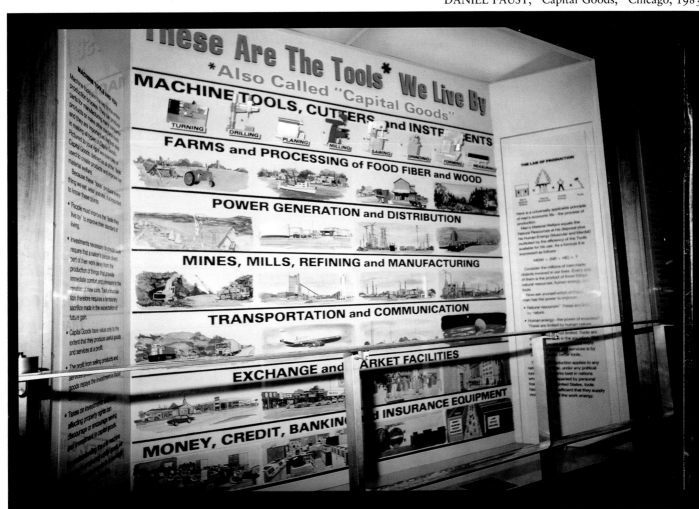

One Journey to China

By Reagan Louie

It is not difficult for me to imagine that a village that seems to have grown right out of the earth but is about to be razed and replaced by ungainly apartment towers could be my ancestral home. Nor is it hard for me to believe that those peasants who are eagerly building these complexes and will eventually enjoy their modern conveniences are my cousins. The China that I experience and photograph is created as much by my need to join together a divided self as it is by the country's dramatic technological and social transformation.

I first drew this analogy when I traveled with my father to his village in Canton. Everyone in Wing Wor seemed to recognize us when we arrived. I was baffled by our reception. I had assumed that we would be virtual strangers. After all, my father had left so long ago—nearly sixty years. I knew that he had been writing to, but had never seen, a distant cousin. When I entered my cousin's home, I saw the reason for the villagers' familiarity. Lined along the gray brick walls were carefully framed photographs of my family. My father had faithfully included our family snapshots with his letters and remittances. There I was, from babyhood to barely six months earlier.

Over the years, the damp heat of southern China had melted the emulsion of all the color snapshots. Our images appeared almost alive in oozing new shapes and countenances. Halfway around the world, in this remote picture gallery, my family history was being transformed by a place and dreamed about by people who I hardly knew existed just minutes before. At that moment, dazed by the intense heat, by the villagers' and my own excitement, and by the source of our recognition, I sensed that a circle was being closed.

My stay in the village exposed a part of my life that I had lived but had never seen. Time collapsed into a single hallucinatory moment. The past was continuously re-forming itself into the present. Wherever I turned, I saw the familiar in the unfamiliar. I recall photographing a village vegetable garden and discovering the same vegetables my father had grown in our back yard. In America, the same plants looked exotic, out of place; here the plants looked perfectly in place. While photographing rituals practiced by these superstitious country Chinese, I remembered how these same acts, when performed by my family at home, struck me as being slightly antic. In China, the rituals to insure good harvests and fat pigs, or to appease field spirits and kitchen gods, seemed natural.

The present also yielded the future. Whenever an airplane flew overhead, the villagers would stop and stare, and if I were nearby, they would shake their heads, unable to comprehend how my father and I had traveled there by air, how it all worked. But they had irrefutable evidence, in our very presence and in

REAGAN LOUIE, Hong Kong, 1985

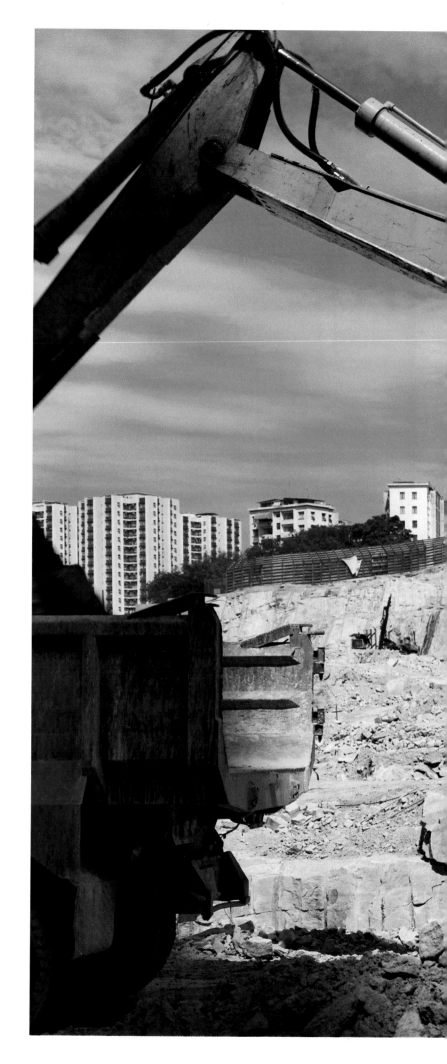

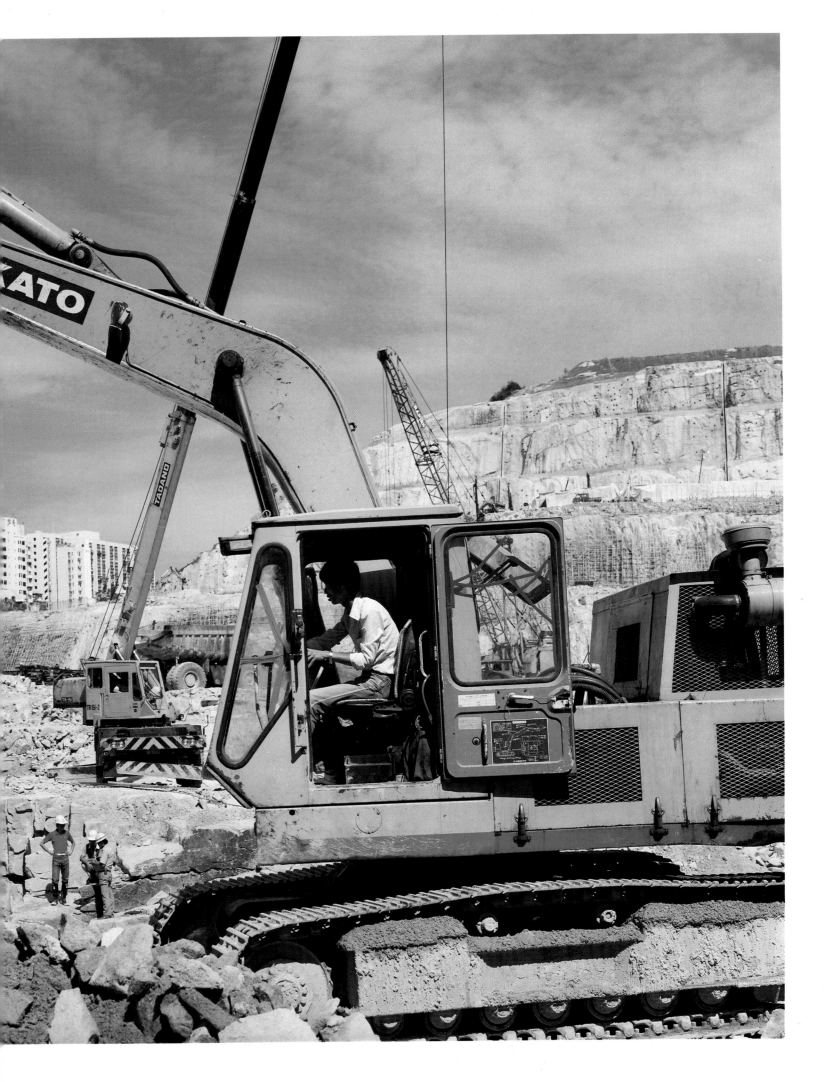

those family photographs of our life in America, that it did work, that it worked very well. Other circles were being drawn.

As the first native son ever to return, my father was no less than a local hero. From morning until night, villagers begged him to tell tales about "Gold Mountain." His return was more than symbolic; it was actual. He moved back through time and memory and became once again that barefoot boy lazily tending the village water buffalo. Witnessing his transformation released a torrent of thoughts, including some about destiny. We are, each one of us, connected to something larger. We seldom, if ever, think about it. Mainly, the connection is lived through in our day-to-day existence. Were it not for an opium war, a gold rush, a transcontinental railroad, and a famine, my father most likely would not have left his village, and this story, if it were told at all, would be very different.

In a slow frenzy, I was trying to fill in a chasm—the before and after of my father's life. I knew I was measuring my life as well. Rationally, it made elegant sense. The simple necessity of survival forced this peasant boy to leave his home to find a new life in a foreign land. I could see that he left reluctantly. I felt his ease in being here. I could feel his connection. He was at home. For the first time in many years, I looked steadily into my father's eyes. They always seemed to be filled with tears.

I wish I could say that sharing my father's journey, and understanding how it caused my own, was an easy process. But I cannot. Competing with all the revelations—the vegetable garden, our family snapshots, my father's rebirth—were so many memories and feelings that I did not want. I envied my father's connection to his village. It was one I could never share. It was not my home. I did not have my father's blood knowledge of this place. Being distantly related allowed me to overcome the peasants' fierce suspicion of outsiders. But my own suspicion of myself—of my motivations for being here—was less easy to dispel. I was, above all, a photographer. I was an outsider.

When I decided to study art, I felt the need to completely separate from the whole weight of my Chinese self. I am Chinese-American. Rigid Old World traditions and elastic New World myths make conflicting claims on my life. My father spoke only Chinese to me when I was a child yet named me after Ronald Reagan, star of the 1951 hit movie *Bedtime for Bonzo*.

My decision to separate was probably made for me on the day I entered school. Except for a few stray words, I could not speak English. I learned quickly. And, as quickly, I unlearned Chinese.

All during my schooling, I was gradually cutting away from custom and my past. I knew from my first recreational college art class that I could not fulfill my father's expectations and become a professional: a doctor, a lawyer, or at the very least

REAGAN LOUIE, Hong Kong, 1985

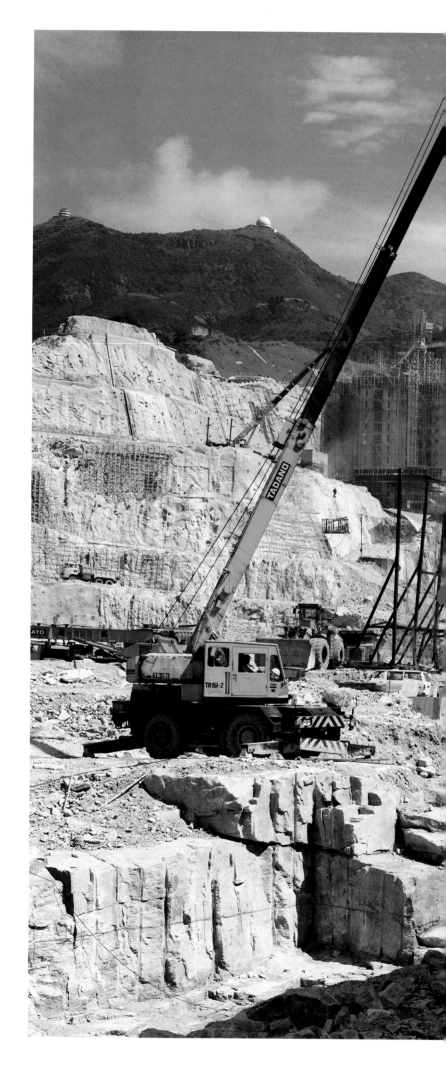

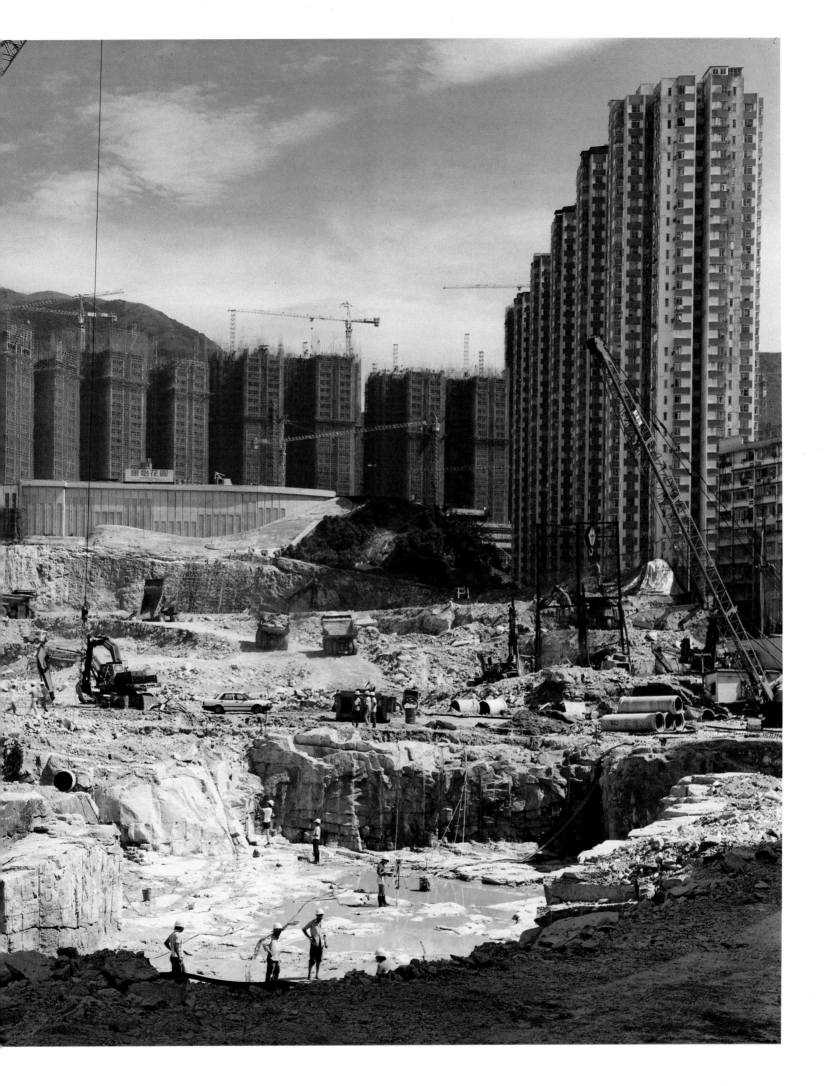

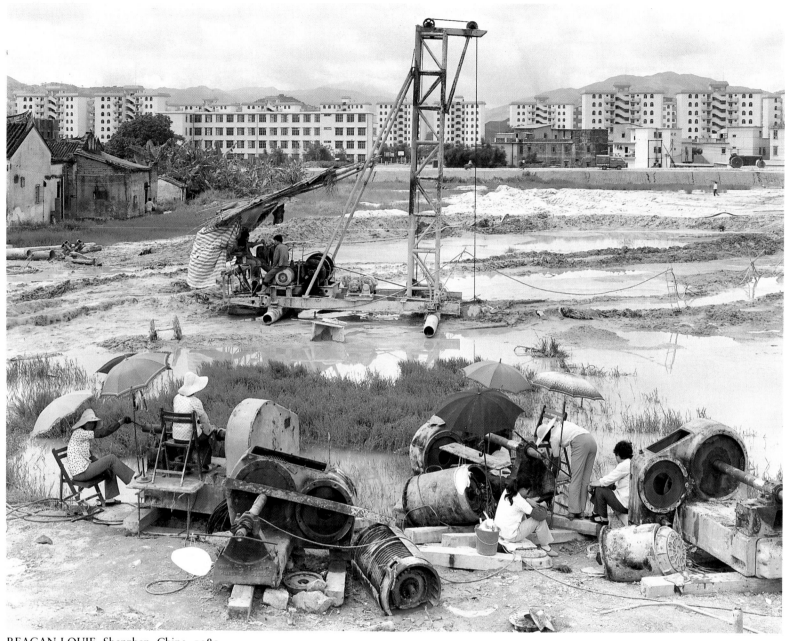

REAGAN LOUIE, Shenzhen, China, 1985

a pharmacist. I could not explain my desire to be an artist since I had little understanding of it myself. There was no reason for pursuing such an improbable career. There was no history. By refusing the role expected of a Chinese son, I created a gulf between my family and myself.

It took me only three and a half days to drive 3,000 miles across the country, after a six-year absence, back to my boyhood home in Sacramento. I had just graduated from college. I had no other place to go. At the time, I didn't know exactly why I had to return. I just knew I had to. Somehow, I recognized that

I had to cast a new identity for myself in my old world, full of reminders of who I had been and cues for who I was supposed to be.

Everything and every occasion seemed to be filled by my struggle. I remember evenings when I would chase my parents out of their living room so that I could look at slides of my work. Each time, I would shudder at my callousness and grow tenser about this activity I so dimly understood. Often, as I sat in that darkened room viewing the projected slides on the wall, I would glance through the window, across the street, to my

REAGAN LOUIE, Shenzhen, China, 1985

father's corner market. At other moments, my gaze would turn from those glowing Kodachromes to the flatter but somehow more real family snapshots sitting on top of the television set next to me, and my past would beckon and then take me over.

At those moments, when I regretted the loss of my past, I would quickly remind myself of the bright promise of being an artist. It momentarily strengthened my resolve. But the fact is, this separation was terrifying.

Much of this terror revisited me in China. On more nights than I care to remember, all my fractured selves kept me awake with the bitter noise of recrimination. On most days, I photographed in wildly fluctuating moods of wonder, rage, enchantment, and embarrassment. The sources of my behavior, of who I was, haunted me.

Since I did not speak the villagers' dialect and they did not speak English, we could only stare at one another. I rarely spoke, even with my father. My imposed muteness raised and was suffused by a more profound silence. My father and I have never had a highly verbal relationship. He is a man of few words. I learned that his quiet is native; all the villagers seemed to possess

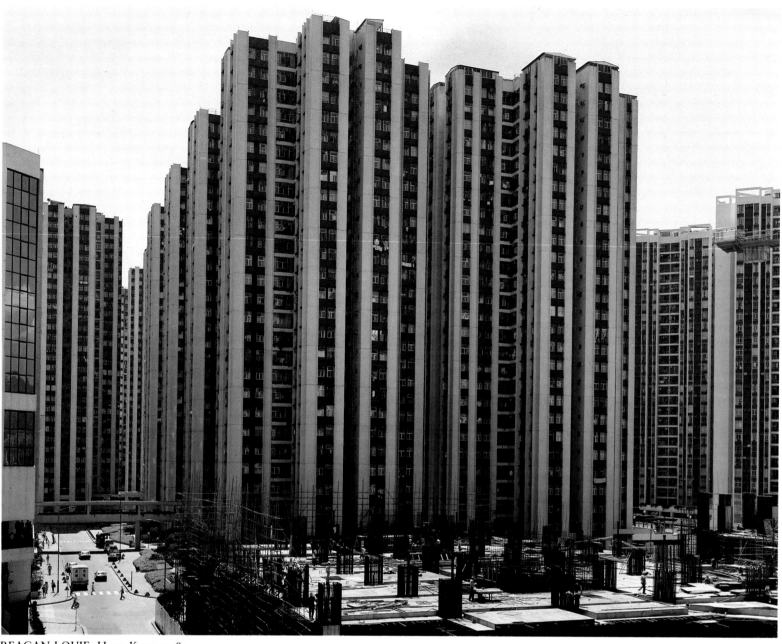

REAGAN LOUIE, Hong Kong, 1985

an inborn reticence. But I also discovered that his silence had a deeper cause, one that was familiar to me. From my own estrangement, I well understood that his separation was too painful to share openly. He could not have revealed the depth of his loss and survived so far away from his home.

When I grew into my silence, I did so, like my father before me, out of a fear for survival. But our silences are of different kinds. Where he grew literally quiet, I grew more abstractly vocal. There is a forced irony to my voice. If my education has helped me to grow culturally divided, it has also given me the ability and means to describe this division. I am wary of this voice. As I write these thoughts, I warn myself against a phrase too well turned, a word too abstract. They may betray me, blocking a connection that I desperately need to make. Each sentence is a struggle against my silence.

There are times when I am even wary of my photographs, especially my "successful" pictures. They, like my words, are well schooled. They may be evasions. "Formalism is repression," I once heard. The more beautiful, the more silent? Still, inescapably, my photographs and my words, wedged between

REAGAN LOUIE, Shenzhen, China, 1985

selves, are double edged, both cause of and cure for my separation.

I have no doubt that this separation and the need to close it brought me to China, to my father's home. On our last day in the village, I remember watching my father, in front of his old house, holding my cousin's baby. As I sat across from them, fanning myself against the heat, they blurred into scenes I recalled from two old family photographs. I stepped sixty years back, and in front of me stood my father as a child leaning against his father in the doorway of this house. A moment later,

I was in old Sacramento, where my father was proudly displaying his new son in front of his new market, called the American Way.

In the clearest moments, I see myself as a transitional figure, bridging cultures and maybe even time. Journeying back with my father to China taught me that he too is a transitional figure. I'm continuing a passage that began when he left his village. Only, instead of exploring a new physical territory, I'm charting a new psychic region. It's a shifting ground somewhere between East and West, knowledge and need, then and now.

Power Source: The View from Colstrip, Montana

By David T. Hanson

Colstrip, Montana, is the site of one of the nation's largest coal strip mines, along with a coal-fired steam-generating plant and the modern-day factory town that has grown up around it. Colstrip is in southeastern Montana, just north of the Northern Cheyenne Indian Reservation. Situated 3,200 feet above sea level in an area where the High Plains rise to meet the Rocky Mountains, Colstrip is flanked on one side by open rangeland, dryland farming, and ranching (mainly cattle and wheat), the terrain a mix of yucca, sage, native grasses, and occasional pine in rolling hills, buttes, and coulees. On the other side are the rising green-forested foothills of the Bighorn Mountains, themselves foothills to the Rockies. Wyoming and southern Montana are extremely rich in minerals and other natural resources, and the area has become a prime example of "energy colonization," serving the dominant interests of the East and West coasts, which need the rich deposits of coal, oil, gas, oil shale, uranium, copper, and other metals buried there.

The coal mined at Colstrip is part of the Fort Union Formation, which underlies much of eastern Montana, Wyoming, the Dakotas, and Saskatchewan. The Fort Union is essentially the bottom layer or base rock of modern geological time, the Cenozoic era, and was formed some 65 million years ago when this part of Montana and Wyoming was near sea level and covered with low swamplands and rising hardwood forests. As the mountains to the west began to lift, they shed mud off their slopes, burying the existing vegetation, cutting off oxygen and preserving the carbon. Gradually, over eons, the compacted vegetation was increasingly buried to depths and at pressures that caused it to become a soft and flaky subbituminous low-sulfur coal. With the shift and uplift of the Rockies, wind and water slowly cleared away more than 5,000 feet of earth, leaving only 30 to 100 feet of soil on the 25-foot seam of coal below.

In 1924 the Northern Pacific Railroad created the town of Colstrip when it began mining coal in the area for its steam-powered locomotives. In 1959 Northern Pacific, having switched from steam to diesel power, sold the coal leases, mining machinery, and townsite to Montana Power Company. In the early 1970s, with increasing energy crises besetting the nation, Montana Power built Colstrip 1 & 2 and, from 1980 to 1984, Colstrip 3 & 4. This power plant is the tallest building in Montana, its stacks rising more than 700 feet. Each year it produces more than 2 million kilowatts of electricity, twice as much as is consumed by the entire state. Roughly two thirds of all the electrical energy produced at Colstrip is exported to the Pacific Northwest through an extensive system of power-transmission corridors cutting a 300-foot swath across nearly 1,000 miles. Less than one half of the coal mined at Colstrip is consumed by the plant; the rest is shipped in coal trains to the Midwest.

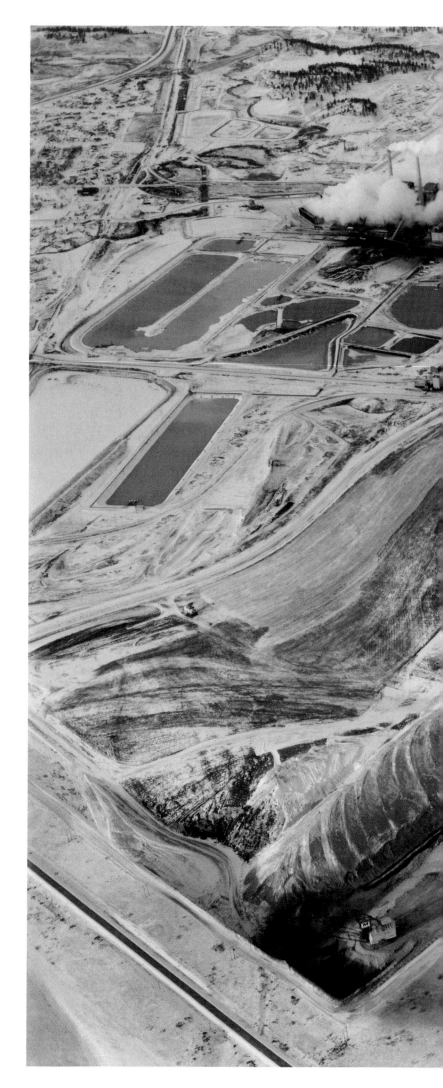

DAVID T. HANSON,
Coal strip mine, power
plant and waste ponds,
January 1984

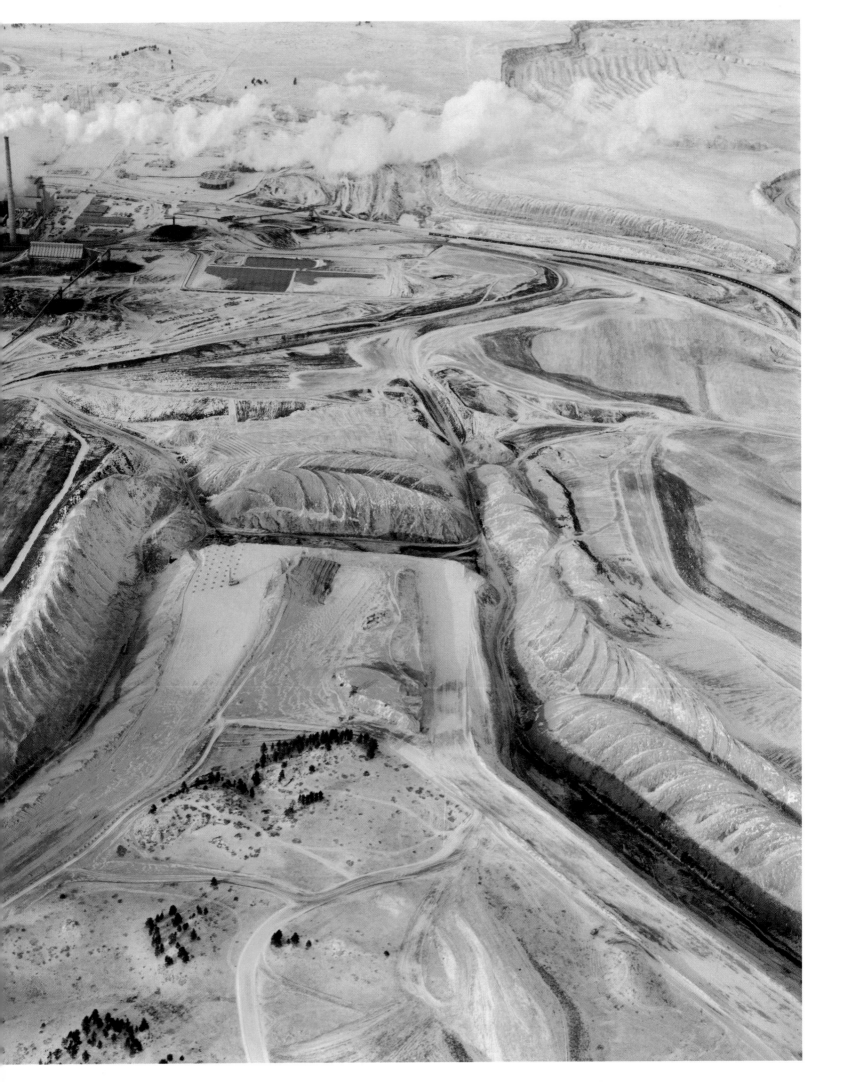

The strip-mining process is relatively straightforward. After a 10-to-20-year mine plan, consisting of a vast-grid of 1-to-2-mile-long bands mapped out across the landscape, has been worked out and approved, the one-foot layer of topsoil and the subsoil are removed and stockpiled for later use in reclaiming the disturbed mineland. The overburden below—layers of sandstone, shale, and clay—is drilled, packed with plastic explosives, and blasted to loosen it and make its removal easier. A fleet of mammoth power shovels do the major work of clearing away the earth and rock to expose the continuous seam of coal lying below. The largest of these "draglines" at Colstrip is the Marion 8200, an 8-million-pound walking landship that had to be assembled on site over eighteen months at a cost of nearly $20 million. The size of a large office building, and containing control rooms and power decks, it has a boom that reaches more than 300 feet out over the earth and carries a huge shovel that can move 100 tons of rock at a single bite. The dragline slowly works its way up one strip and down the next, systematically filling in the previous strip as it exposes the next one. Over the past 60 years the Rosebud Mine at Colstrip has mined more than 100 million tons of coal. Enough earth has been moved to fill both the Erie and Panama canals twice over. Yet across eastern Montana there remain more than 50 billion tons of coal that are accessible by strip mining, one third of all the coal resources in the United States available for surface mining.

After the coal seam has been exposed, drilled, and blasted, it is shoveled into coal haulers, which truck it to dump sites where the coal is crushed and then transported on conveyers to storage areas or waiting railroad cars. From the storage piles the coal is fed into the power plant to fuel giant steam-powered electricity-generating turbines. However, for a plant so dependent on water to fuel and cool its steam generators and to flush out its waste products, Colstrip is in a surprisingly dry area, 20 miles west of the Tongue River and 30 miles south of the larger Yellowstone River. The solution has been to build two large pipelines to tap the Yellowstone. The plant consumes nearly 22,000 gallons of water every minute; a 50-day backup supply stored in a large reservoir also serves as the town recreational facility. Surrounding the plant and town is an extensive system of waste ponds containing a variety of waste products generated by the plant. The majority of these ponds are settling ponds, in which the suspended waste material slowly sinks to the bottom, where it can be dredged up and trucked away to dump sites nearby. There are also a number of warm-weather evaporation ponds, in which the waste water is channeled through a large system of sprinklers that spray it out into the air; the water evaporates, leaving the dessicated waste on the ground. Inevitably, the waste from the various ponds works its way down into the underground water table and into the local and regional streams and rivers used for irrigation, farming, and livestock. In addition, the billowing plumes of smoke emitted from the stacks carry yellowish clouds of sulfur dioxide

DAVID T. HANSON,
Waste ponds and evaporation
ponds, June 1984

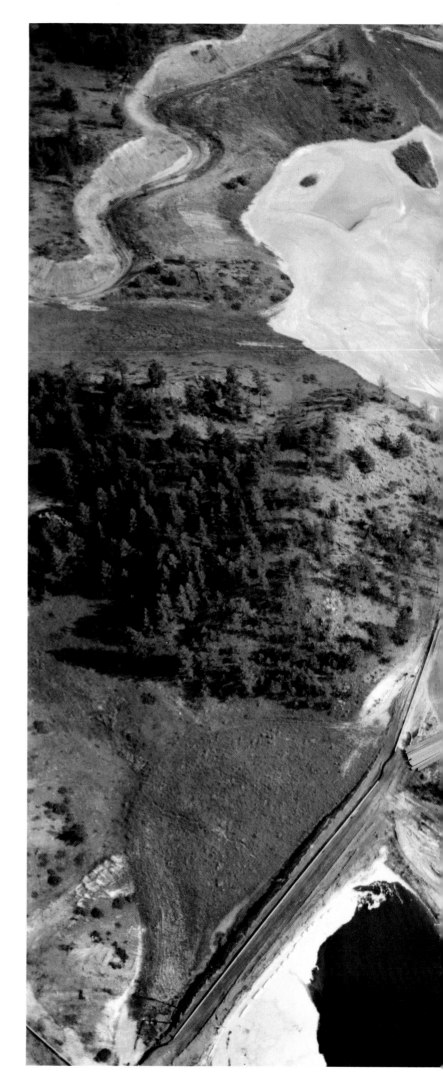

across much of southeastern Montana and parts of Wyoming and South Dakota, causing sulfuric acid to precipitate onto the landscape below in cold weather.

The final stage of the mine process is the reclamation of the mined land with its series of giant furrows across the landscape. Current federal and state law requires that the earth be filled back in, graded to the approximate contours of the original terrain, covered with subsoil and topsoil, and seeded with a mix of trees, shrubs, and native grasses resembling the regional vegetation. Although some mined land at Colstrip has been reclaimed, primarily in high-visibility areas along highways or in one or two public-relations reclamation plots, most disturbed land has been unreclaimed or only partially reclaimed.

The most difficult aspect of mine reclamation is reconstituting the groundwater system. The mining process inevitably disturbs or completely cuts off the topography's natural drainage patterns. The major aquifers in the area are in the coal seam and in some sandstone layers in the overburden. The aquifers are disrupted indefinitely when they are intersected by the mining and polluted with silt, heavy metals, and acid drainage from the spoil piles. In this semiarid terrain, the barely-adequate water supply is critical for agriculture and grazing. Some wells are drying up or being contaminated.

At the time these photographs were taken, from 1982 to 1985, more than half the population of Colstrip lived in mobile homes and trailers. Following the completion of construction of the power plants, the population has leveled from a peak of 8,000 and the town of Colstrip is beginning to more reasonably approximate the "carefully planned, award-winning community of 5,000 residents" that the company promotional literature advertises. It remains, however, a strange and disconcerting version of the middle-American small town, in many ways a classical late twentieth-century factory town. The power plant and stacks, with their billowing clouds of steam and yellow-stained smoke, tower over the town. Nearly all the residences are in direct line of sight of the plant, and with its constantly flashing lights, the drone of the turbines and cooling towers 24 hours a day, and the intermittent, clearly audible stream of loudspeaker pages for workers throughout the site, it remains the primary focus of the environment. There is also the insidious dust from miles of exposed soil and coal piles that, in this dry and windy part of the Northern Plains, works its way into everything within the area—trailers, houses, cars, and stores included. Swiveling draglines are visible beyond neighboring houses and stores, regular sirens warn of explosive detonations, and the reverberations of the blasts can be felt beneath the earth. Steel transmission towers and high-tension power lines dominate the sky, often close to or directly above the houses and mobile homes. Surrounded on nearly all sides by the power plant, industrial site, strip mines, and waste ponds, the town of Colstrip is dwarfed in size and import by the industrial activity that spawned it.

DAVID T. HANSON,
Power switching yard,
R.V. Camper Village and
Industrial site, June 1984

51

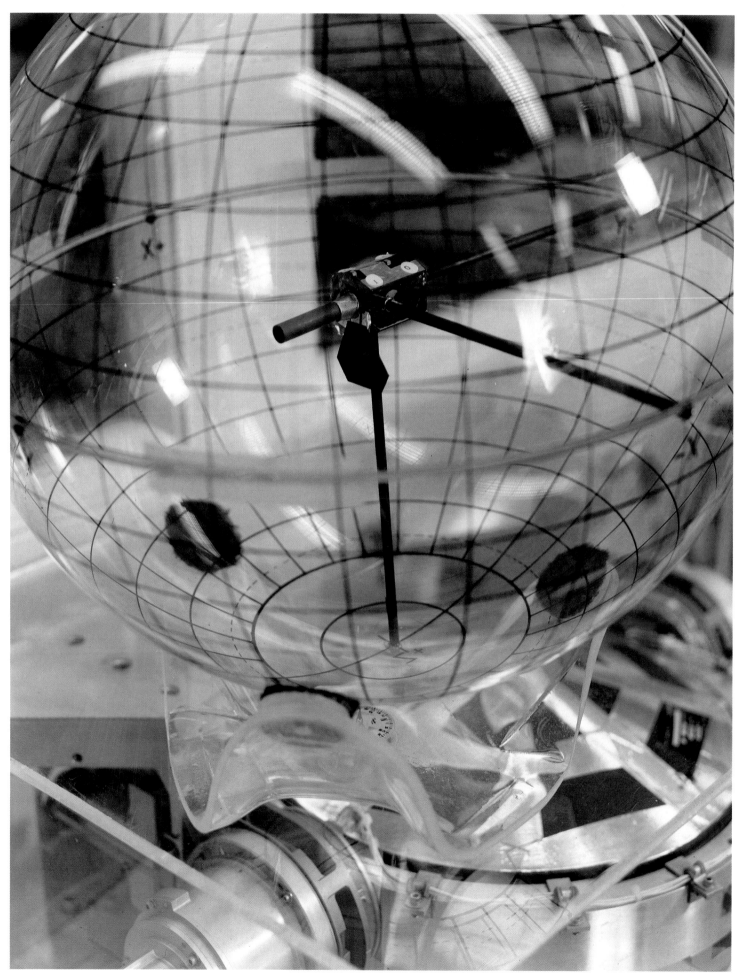

ROBERT CUMMING, Satellite in Earth-orientation Sphere, 1986

ROBERT CUMMING, X-Ray Chrystallography Mounts, DNA Research, 1986

Threads of Nature: The MIT Photography Project

By Robert Cumming

As men of enlightenment, and of God, were beginning to conclude that the Noah myth of the Deluge was no longer a credible explanation for the tons of petrified bones of gargantuan reptiles, for the lush fern forests and the dragonflies with bodies the size of ax handles found turned to coal in the deepest mines, the earth was beginning to look a lot older than the three thousand years assigned by the Bible. Poe seriously fantasized that the poles were the points of great whirl-pools that drained deep into the earth, with the water seeping throughout the globe in underground caverns and watercourses to emerge as the headwaters of the earth's great rivers (especially the Nile, whose mysterious source had eluded Western civilization since the time of Caesar). Throughout Western culture, however, the early to mid-1800s saw an unprecedented surge in the application of the scientific method that would demystify the mechanisms of nature. The same decade that Darwin applied himself to the problem of natural selection on his *Beagle* voyage, Fox Talbot, Niepce, and Daguerre found a means to permanently fix a sun-

ROBERT CUMMING, Crystal Growing Kilns, 1986

ROBERT CUMMING, Diamagnetic Loop, Antenna, Interferometer
Inside "Constance." Plasma Fusion Experiment, 1986

exposed image to a flat surface. As earth science progressed, catalogues of animal and vegetable species came to completion, and geologic study better defined a vaster chronology of earth events. The Rosetta stone was deciphered in 1822, Homeric Troy was discovered in 1870, and by 1900 there were scant blank spots on the maps. Soon, the planets all had names and the Nile burbled out of ignoble dirt like any pasture brook.

The consequences of a science that expanded exponentially followed closely by a growing technologic arsenal suggested a demystification of the primary laws of nature in the century ahead. In a perfect Newtonian system, ultimately predictable and regular as a pocket watch, the answers to all the questions of the natural world were attainable in time. The problem with the questions and solutions of our century is not in their ultimate obscurity but in the sheer number of new questions each answer uncovers. A single theory can open a handful of new subsciences. And in the twentieth century, the answers begin to appear more as riddles, yielding aspects of nature more mysterious than any

lugubrious Romantic allegory, worlds within worlds further beyond the imagination than any concocted Surrealist landscape. Paradox and fact, conundrum and natural law appear indistinguishable. Out boating with three children one summer's day in 1862, Lewis Carroll, and Oxford mathematician, logician, and photographer, spun one of his usual fables. He later developed "Alice's Adventures Underground" into a more substantial work for publication. One imagines his intellect stirred by a playful, less pedantic soul of nature as revealed by discoveries of the new century.

Assume we have in hand a chunk of carbon the size of a stick of butter. The atoms that give it body number 600,000,000,000,000,000,000,000, give or take trillions. Few can internalize numbers past a million, so to bring this impossibly long string of digits to closer range, imagine the following. Our universe is now thought to have originated about 15 billion years ago. Had we begun then to remove the atoms one at a time at the rate of one every second, by the twentieth century, we would have removed only one millionth of the carbon chunk's mass, or something like the number of atoms scraped off on a piece of paper when we make a hyphen between words with a sharpened pencil. Small as that makes the atoms, most of the area within and around them is empty space. At the atom's core is the nucleus (an amalgam of particles); around it is a single electron or a halo of electrons. The spatial relationship of the nucleus to the electron(s) is something like that of the head of a common pin at the center of an enclosed sports stadium to the perimeter. Yet for the last couple of decades of particle research, the nucleus has been a very large entity. Inside and around the atom, more and more particles keep coming up: pions, kaons, hadrons, leptons, muons, bosons, ions, gravitons, gravitinos, antiprotons, quarks, photons, neutrinos, etc.; 200 new creatures in the particle zoo, and the number keeps climbing. And each demonstrates unique properties. A neutrino, for instance, is so massless that if a stream of them were fired through a stack of lead from here to the moon, most would pass through unhindered.

Much has been made of the undoing of the past's sense of firm footing by Einstein's demonstration of his theories of relativity. Time and all that made up our touchable, seeable, three-dimensional day were no longer constant. In the 1920s, Heisenberg's uncertainty principles of quantum mechanics (governing the behavior of electrons) threw yet another wrench into the smoothly meshing gears of Newtonian reality. The distortion of time and mass in Einstein's theories constituted a new, fourth dimension, one that had gone unnoticed because it occurred only on vast stellar scales at speeds close to that of light. All the attention given the ultrasmall atomic subparticles for the last forty or fifty years is producing speculation that leaves the properties of a fourth dimension looking elementary. If relatively had gone unnoticed because of the hugeness of scale involved, it is now suggested that there are further dimensions that kick in at the particle level—seven, maybe ten—unnoticeable in the everyday because of their ultrasmallness. Down there, it now seems possible for particles to get knocked backward in time, for mirror realities in which every particle has an equivalent ghost of antimatter, among other perplexities.

The nonvisible nature of phenomena being investigated at MIT (and elsewhere) was foreseen as a problem for a documentary photo project. These are photos of very complicated exteriors, the shells of machines within whose special environments the threads of nature are sorted, measured, manipulated, torn, and recombined. There are temperatures of 70 million degrees Celsius confined in bottles of magnetic fields, bursts of special light equaling the power of New York City at a given instant, and measurements of pulses of light closing in on one trillionth of a second in duration (a femtosecond). This is no more evident in the photos than is a Chinese dinner in a picture of chopsticks or the human digestive system in a photo of the navel. If a rationale for the pictures beyond the purely formal, or exotic, is needed, it is the rapidity of technologic obsolescence. In disciplines of such flux, today's state-of-the-art equipment is tomorrow's dinosaur. The change in the visual texture of former labs is evident in photos taken in the 1950s, when alien-looking vacuum tubes tell of a pretransistor technology. Photos from 1900 to 1920 look like artifacts from some far earlier beam-and-bolt era, huge electromagnetic contraptions from the Frankenstein lab. Common features today are the indispensable duo of computer and laser.

Despite their sophistication of design and purpose, many of the machines pictured are the first of their kind—prototypes. Overhauls for major concept and design changes are expensive and time consuming, so whenever possible, additions are made ad hoc; these can be in the most rudimentary chewing-gum-and-paper-clip mode. At a trillionth of a second, light is still blocked efficiently enough by a matchbook, and when a building settles under the weight of a huge new machine, a simple pine wedge, a doorstop, shims things plumb, as its ancestors have done since the days of Noah.

1. The photography project was organized by the MIT Committee on the Visual Arts with support from the Massachusetts Council on the Arts and Humanities to document the look and feel of new technology around the Greater Boston area, defined by Route 128. Jan Groover and Lee Friedlander are also project participants.
2. The example of the universe-long removal of atoms from the carbon bar is owed (with a few changes) to John Gribbin's *In Search of Schrodinger's Cat,* Bantam Books 1984.
3. Lest the preceding be read as unbounded technologic boosterism, let it be added that any advances always embody darker aspects. He who owns the information of the future owns the world. And if there is enough energy in a glass of water to fuel a nation, and there are computers that make a trillion calculations per second, it is inevitable that the world can be brought to an end with the might in that glass of water, with only two trillionths of a second to give the matter a second thought. *MIT* receives major Defense Department funding, much of which is applied to Star Wars-type research. The fifteen minutes it now takes to eradicate civilization as we know it will seem a golden nostalgic eon in the fidgety future.

ROBERT CUMMING, Satellite, Lincoln Labs, 1986

Patterns of Light

By Kira Perov

KIRA PEROV, from *Anthem*, by Bill Viola, 1983

In 1969, Vito Acconci quietly performed a solitary piece walking along a street in downtown New York. He had decided to try to walk without blinking his eyes. When he finally did blink, he took a black-and-white photograph with a simple instamatic camera. By the time he finished the roll of film (twelve shots or so), he had assembled a documentation of everything that he had missed seeing at the moment of each blink.

It is enlightening to view artists' videotapes with the intention of photographing them to obtain a still image. Some tapes are easily summarized and can be represented by one image; more often, to take a still from a tape is like trying to define a blink, to grab at an elusive image that wants to disappear in time. Acconci was successful in recording that moment, governing his choice of image to some extent by willpower. Capturing one still frame in video time is a reversal of Acconci's action. A video frame is a continuous process of motion that, even when still, depends for its existence on endless self-repetition every 1/30th of a second. There is never a "still" image. An unconscious tension is created between this electronically scanning pattern of light and the content of the image it represents. Our perception and, later, our memory of a video work depends on how well our brain can assimilate motion into meaning. To extract one frame from most tapes means creating a disparity in vision—a still frame is an abstraction and exists separate from the whole.

This disparity can be seen by comparing two works, *Sunstone* (1979), by Ed Emshwiller, and *Global Groove* (1973), by Nam June Paik. Each frame of *Sunstone* was created entirely on a computer imaging system where time and detailed control of every pixel is possible. The work takes us through a series of gradual metamorphoses of a lifelike electronic face synthesized by Emshwiller. Because the essential character of the face does not change throughout the work, an image can be extracted at any point that adequately represents at least the artist's visual concerns. Paik's work, by contrast, uses the cinematic device of montage to barrage the viewer with a collage of real and imaginary electronic spaces. His fast-paced editing also serves to create shifts in time so frequent that it is impossible to summarize the tape in one image; an individual frame becomes an arbitrary example in relation to the whole.

The search for a single frame can be compared with the process of editing; it actually comes closer, however, to the practice of archaeology. In editing, the frame is seized, put in place in relation to other frames, and then allowed to submerge again into the subliminal time structure of the piece. In video photography, the frame is brought up from the depths but never released; it remains before us. Therefore, most of the concerns in capturing still frames of video return to the area of traditional still photography. The conventional visual elements of composition, color, and lighting come to the forefront in the search for a single image that communicates both the artist's idea and a strong graphic representation. This can stimulate an interesting dialogue between the still photographer and the work, and it becomes a very effective tool of visual analysis. Video techniques used by the artist, such as the juxtaposition of two images in a dissolve, become visible. In *Double Lunar Dogs* (1984), the special effects used by Joan Jonas serve to create a new world, one that is familiar but has the ability to exist simultaneously on several planes of time and space. Occasionally these planes combine in an image dissolve, and communication between them is established. These "dissolved" moments are the key to the interpretation of Jonas's creative language.

Translating from one medium to another—in this case from an original electronic video signal to the chemical emulsion of film—brings new insights. No longer is the image luminous. It does not emit light but is merely recorded with the aid of light. Yet even without its electronic luster, the power of the image remains undeniable. Film is sensitive enough to record and reproduce the infinite range of electronic colors possible in video. The ability to manipulate color and to freely combine forms in one image frame enhances the surrealistic quality that often characterizes electronic art. In these works it is sometimes unclear where the electronic realm begins and where it ends. In *Prelude to the Tempest* (1985), Doug Hall uses spotlights of color to transform and dehumanize a face. Similar surrealistic effects are often the result of electronic manipulations.

It is clear that the video medium is capable of producing striking graphic images of great subtlety and beauty. It will soon become an important tool in the still-making process, as a few pioneering designers are now demonstrating. Studying the works

KIRA PEROV, from *Global Groove*, by Nam June Paik, 1973

of video artists as stills in a series, a technological evolution can be seen from early unclear black-and-white images made on primitive equipment to the sophisticated high-resolution images recently produced in state-of-the-art studios. It is evident that technological evolution and creative possibilities are closely aligned. From our perspective today, all these examples of image quality are equally effective. The earliest video works begin to take on a mysterious aura, much like early nineteenth-century photographs. A comparison can also be made to the still pho-

tographer's inclusion of "undesirable" imperfections of focus, motion blur, and grain, as important aesthetic elements.

My interest in shooting video stills has not necessarily stemmed from chronological concerns, nor do I wish to select the most "important" or influential tapes in video art's relatively short history. By recording video with another medium, I have tried to bring a new understanding to the whole body of work, one that places it within a history of image making that includes film and photography.

top) KIRA PEROV, from *Prelude to the Tempest*, by Doug Hall, 1985
bottom) KIRA PEROV, from *Leaving the Twentieth Century*, by Max Almy, 1982

(top) KIRA PEROV, from *Viva Magritte*, by Ros Barron, 1983
(bottom) KIRA PEROV, from *Double Lunar Dogs*, by Joan Jonas, 1984

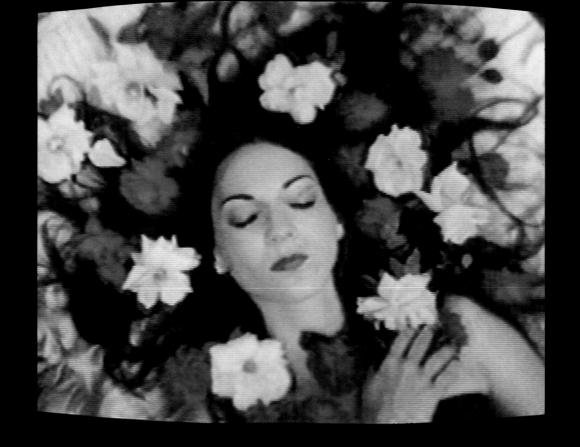

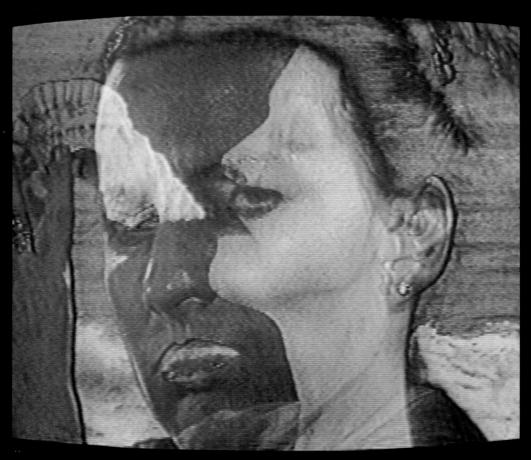

(top) KIRA PEROV, from *Possibly in Michigan*, by Cecilia Condit, 1983
(bottom) KIRA PEROV, from *Double Lunar Dogs*, by Joan Jonas, 1984

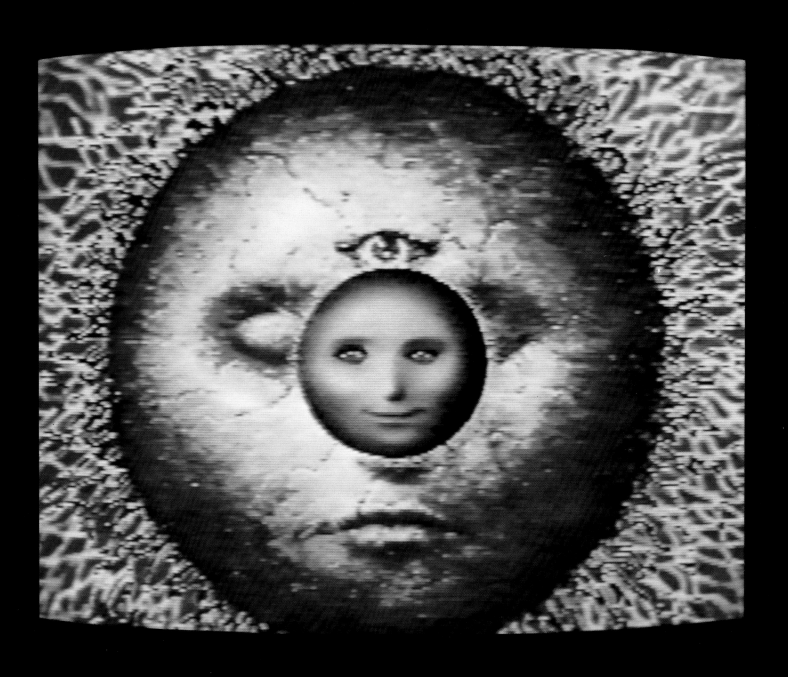

KIRA PEROV, from *Sunstone*, by Ed Emshwiller, 1979

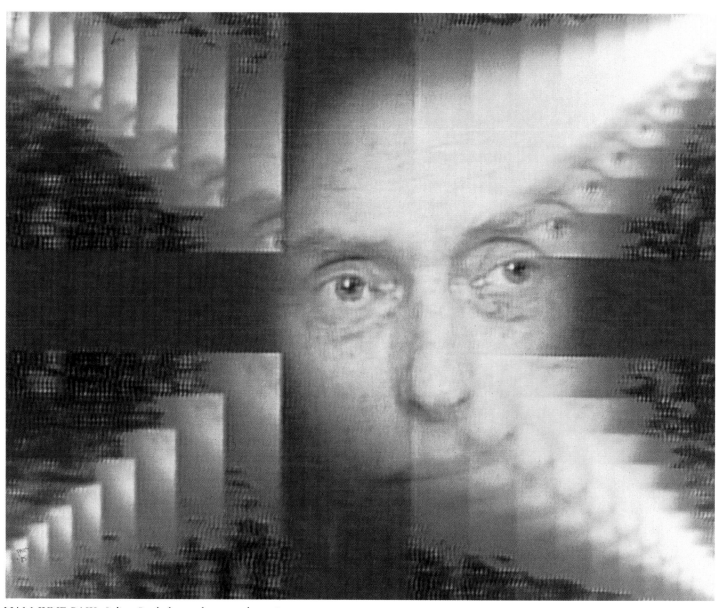

NAM JUNE PAIK, *Julian Beck*, laser photograph, 1985

People and Ideas

TELEVISION'S IMPACT ON CONTEMPORARY ART
by Marc H. Miller

When television made its official debut at the 1939 New York World's Fair, it was heralded as a key feature of "The World of Tomorrow." People thronged to the RCA pavilion in Flushing, Queens, to see the new invention that promised to bring moving pictures and synchronized sound into every living room across America. Although the promise of TV was temporarily delayed because of World War II, public response to its reintroduction in 1946 exceeded the expectations of even its most ardent boosters. Within a few years, as the price of sets fell, millions of TVs were purchased and hundreds of broadcasters began serving up programming. Today, with more than 86 million televisions in 98 percent of the homes of America, and the average person watching more than thirty hours per week, there are few who have not been touched by the new medium.

Television has had a particularly powerful effect on visual artists. As TV has assumed its place as a principal source of visual information, it has radically altered the visual climate both in the way images are presented and in the range of content. Many artists have adopted the new medium to make video art, but TV has also affected the style and content of works done in traditional mediums. The dynamic of this response recalls the nineteenth-century arrival of photography, a new visual medium that affected the subject matter and style of many artists, both realists and Impressionists.

In the 1960s the first wave of TV-influenced art appeared. Now in the 1980s the first generation to grow up with TV has come to maturity. Weaned on the tube, the "electronic babysitter," these baby boomers are producing a deluge of TV-inspired works.

Artworks produced in response to television are a far from uniform group. This is not surprising, since TV is a passive tool of communication suited to many purposes. It serves revolutionaries and reactionaries, gratifies hedonists and inspires evangelists, shows us nutrition experts and sells us junk food. TV offers itself equally to the wide range of aesthetic and philosophical inquiry that makes up contemporary art. Despite the pluralism of TV-inspired work, there are some basic ways in which artists have interacted with TV.

The TV set itself has emerged as subject in numerous works of art. A quintessentially modern piece of furniture, it defines a scene as contemporary. As a kind of window on the world, the TV is an evocative motif that, whether in a still-life interior or a figurative scene, radically alters the mood. Its phosphorescent glow provides artists with a new type of light; its depiction infuses a scene with distinctive new feelings.

Artists have also focused on TV programs, which provide an endless stream of subjects. The constant flow of entertainment and news shared by Americans (and by people around the world) has in large part replaced literature and newspapers as common culture. In depicting this public subject matter, the artist knows that what has a strong effect on him has had a strong effect on others. It is a new kind of history painting.

The new electronic technology has stimulated artists to imitate the distinctive

Lewis Stein, from *Surveillance Series*, 1984–1985

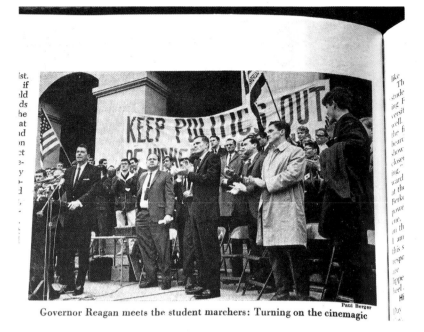

Governor Reagan meets the student marchers: Turning on the cinemagic

Newsweek, Feb. 20, 1967

The Newsweek photographer ran out of film and asked me for mine

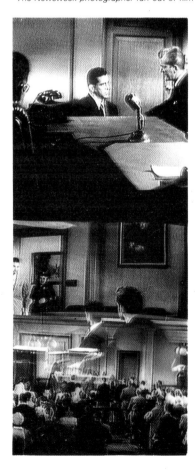

Paul Berger, *Press* (From *Seattle Subtext*, 1981)

visual image that is its result. Painters and photographers have substituted the fuzzy, disintegrating image of the TV screen for the traditional rendering from nature. The technology can spotlight issues in representational art; it can also produce a new kind of abstraction expressive of modern life.

While specific examples of television-inspired art are plentiful, it is still hazardous to track the broader ways in which it has affected the course of contemporary art. Since the 1950s art has moved steadily away from abstraction toward representation, and it is tempting to say that TV has played a role in this evolution. Certainly the incorporation of popular culture into fine-art culture, an important function of representational art since the advent of Pop in the 1960s, has been encouraged by television.

Recently, however, it has become clear that television is also encouraging new forms of abstraction. TV's electronic translation of reality offers a new collection of shapes and colors that are increasingly being adopted by artists. Television has also encouraged a new sort of thinking. As part of a communications revolution that began 150 years ago with the invention of photography, TV has added immeasurably to the glut of visual information. This has led to the current tendency to make art out of recycled or appropriated images. While the TV experience has exposed us to wider, previously unknown realms, it has also led to a distancing from and dissolving of reality, an irrevocable shift away from direct experience.

Television's greatest impact on art lies in its incorporation into art. The arrival of video art as a widespread mode of creativity is fraught with implications. As a machine-made imaging system, TV has taken its place alongside photography, challenging the age-old dominance of handmade painting and sculpture. As a light source generating transient images in time, TV feeds into a trend toward the dematerialization of the object—a new art made from energy and information. As conceived in relation to a system of mass communications, video art has raised new questions about the role visual art can play in daily life. New developments in computer technology contin-

ually expand the possibilities of video art, while VCRs and cable systems broaden its audience. Its future seems bright.

At the same time the Pop artists were working with images related to television, a growing number of fine-art photographers were being attracted to the ubiquitous tube. The pictures of Robert Frank perhaps epitomize this prevailing early style, which was in part documentary and in part an expression of personal sensibility. Powerful evocative motifs were prized, and in the early 1960s many photographers, including Frank, Garry Winogrand, Diane Arbus, Lee Friedlander, and Bruce Davidson, discovered that the presence of a TV in a picture could add a distinctive note. They initiated a photographic genre, a tradition of images of the TV "in situ."

Whether placed next to a Christmas tree, propped up on a chair in China, or found in Elvis Presley's living room, the television adds a new layer of meaning. When the TV in the photo is delivering images, references become more specific. Lee Friedlander relies on contrast and strange juxtaposition. Irony pervades the view of actor-politician Ronald Reagan on the tube in a California suburb in Bill Owen's photograph. The TV picture can

strike a poignant note, as in the view of Robert Kennedy's funeral in a Bruce Davidson photo made in a run-down tenement on East 100th Street in New York.

In a series called "TV Landscapes" Maxi Cohen photographs windows through which TV-illuminated interiors can be glimpsed. The subject of these photographs is the distinctive light of the tube, cool but inviting, which connotes human presence.

As part of a communications revolution that has vastly increased the amount of information we receive, television has greatly added to the bombardment of stimuli that has been one of the principal characteristics of modern life.

This deluge of information started well before television. With their fractured, fragmented, and multiplied images, Cubist and Futurist painters sought to capture the tempo of contemporary city life, which included the new radio, telephone, telegraph, and phonograph, as well as many other new machines. Pop artists picked up fragmentation as a pictorial means of imaging their day, and some, like Rauschenberg, added TV and pictures from TV to the mix.

In photography multiple exposure of-

Thomas F. Barrow, *Game Structure*, 1968

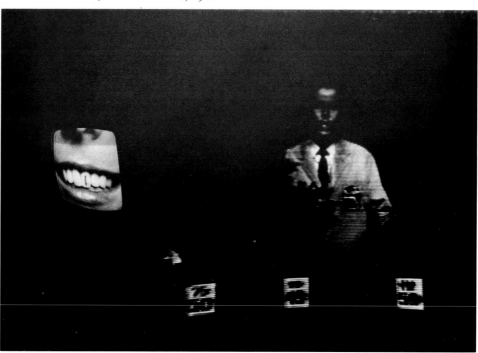

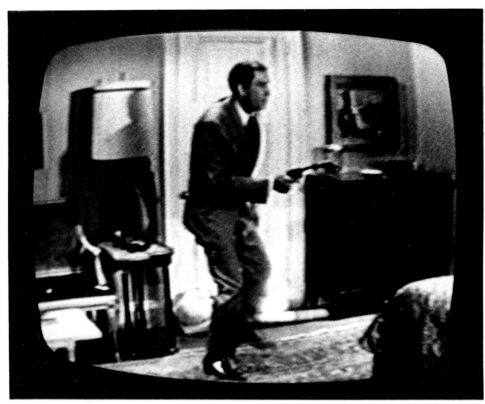

Source photograph for *Perpetual Photo* (below)

Allan McCollum, *Perpetual Photo*, 1982–1986

fered a natural technical means to articulate contemporary media overload. In 1968, Thomas Barrow made multiple exposures of TV pictures, alternating close-ups and medium shots, and changing the distance and angle of his camera from the screen. Multiple exposure was Harry Callahan's approach when he mixed images off the TV screen with shoppers walking city streets on the same roll of film. Paul Berger's photomontages mix charged TV images from news and advertising, thickened with text, in a series commenting on modern mass communication.

The by-product of media overload is a world awash with images, and increasingly artists are opting to appropriate or recycle existing images rather than compose their own. The intents of these media-wise artists differ, but most of them share a bent toward analysis of the public sphere through the public images we are fed on TV. Matthew Geller uses early advertisements for TVs to reveal the medium's impact on domestic life in his book *In a Musty Chamber*. Daniel Faust's photographs of TV characters commemorated as wax-museum figures trace the metamorphosis of these modern post-literary characters from medium to medium. Faust's photographs look like film production shots, except that they are unusually still.

If TV is a ready source of representational images, it is a source of ready-made abstract images as well. While television has inspired some artists to move toward representation, it has encouraged others in the opposite direction, toward the development of a new abstraction.

Traditionally abstraction in art has been based on geometry, organic configurations, and the various effects achieved by applying paint to canvas. The new TV-related abstraction uses space, colors, shapes, and lines generated by electricity. This invisible vocabulary of forms first became visible through television and analytical devices such as the oscilloscope. Playing with imagery derived from this abstract realm was an early preoccupation of video artists, and led to the development of video synthesizers, complex machines that deconstruct the video signal to form eerily colored moving abstract shapes. The advent of computers

offered increased control over synthesizer effects. In his *Perpetual Photographs* Allan McCollum makes the distortions that take place as images transit between mediums the subject of his work. His pictures are basically details of framed paintings that appear on TV, which, when they are enlarged, appear to dissolve into abstraction.

New inventions such as facsimile printers, which work like photocopy machines, make the instant capturing of images off TV even easier. Gretchen Bender uses a Mitsubishi electrostatic printer to appropriate images directly from the TV screen. Carefully edited and presented in series of strips, her choices penetrate the media façade. Robert Longo also uses the Mitsubishi printer as a source of images that he makes into drawings. Through the selection process a distinct sensibility emerges. Longo discovers potent evocative images amid the rich variety available on TV without resorting to the kind of iconic image that emerged in Pop.

The technology of broadcast television was only the beginning. After nearly forty years in America's homes, the uses of TV have greatly expanded. Today's TV is a monitor that can be attached to a camera, a vidoecassette, a computer, a video game, a cable system, or a satellite dish, as well as receive the standard broadcast signals.

VCRs allow a more personal style of TV viewing and the accumulation of libraries of programs. This encourages the distribution of video art, which is too specialized for commercial TV. Audiences now can also get information about art from television. Among the products available for the VCR are figure-drawing lessons by Philip Pearlstein and a videodisc containing every work in the National Gallery in Washington, D.C.

Certainly the computer is having the greatest effect in changing concepts of television and its role in the arts. The computer as subject appears in the work of Haring, Kostabi, and many other artists. Warren Neidich's photograph of a face before a TV screen loaded with text captures the harsh, compelling electromagnetic light as it documents TV's integration into the workplace.

It is in art-making, however, that the computer is having its greatest impact. The TV monitor attached to sophisticated computers is replacing the canvas; the mouse is replacing the brush. While transferring an image from the TV screen into hard copy once required the clumsy task of photographing off a screen, new technology allows a direct printout. Nancy Burson's *Etan Patz Update* demonstrates perhaps the most sophisticated use of TV and related computer technology. This photograph, produced by the artist for the FBI, is intended to picture the child abducted in SoHo in 1979 as he might appear today. It shows the remarkable imaging power of TV as specially designed computer programs reshape the image of a face pixel by pixel, dot by dot.

The future of television offers rich possibilities for art. But it has its ominous side. Don Leicht's painting of video-game "pieces" with John Fekner's words "Your Space Has Been Invaded" reminds us that the new technology is not all fun and games. Though 1984 has come and gone, Orwell's vision of Big Brother is still a real possibility. Lewis Stein's series of photos showing surveillance cameras is a reminder that TV is not just something we watch, but something that is watching us.

This article has been adapted from Marc H. Miller's introductory text to the exhibition "Television's Impact on Contemporary Art," which appeared at the Queens Museum in the autumn of 1986.

NEW FACES
by Art Kleiner

Composites, *by Nancy Burson. Published by Beech Tree Books/William Morrow, New York, 1986.*

Working with two computer scientists, Richard Carling and David Kramlich, Nancy Burson has produced a book called *Composites*—a series of computer-generated, simulated photographs of faces that do not exist. Carling and Kramlich, specialists in designing what has come to be called the person—machine interface, worked to realize Burson's ideas, creating an experimental visual laboratory that enters existing pho-

Nancy Burson, *First Beauty Composite*, 1982

Nancy Burson, *Mick and Keith*, 1986

Nancy Burson, *Big Brother*, 1983

Nancy Burson, *Three Major Races*, 1982

tographs (taken with a regular camera) into the memory of a graphics computer.

Burson uses this simulated laboratory to age some faces before their time—to see, for instance, how Brooke Shields would look with wrinkles—or to foreshadow how a plastic-surgery patient might look after a facelift. But, clearly, her favorite use of the laboratory is to test abstract ideas about people and society. She imagines a metaphorical image about, say, beauty: how would the five most celebrated American actresses of the '50s look combined? For each test, she measures out the required ingredients with an experimental rigor that a chemist might envy—for beauty, equal proportions of Audrey Hepburn, Grace Kelly, Sophia Loren, Bette Davis, and Marilyn Monroe. Then she presents us with the results so we can judge for ourselves and draw our own conclusions. Burson's method of matching and merging pictures is much like sandwiching two negatives to make a single print—but with the computer's precise control over every grain of the final image. The main difference between this and regular darkroom practice is the warping system, the use of grid on which one image can be stretched so its proportions match those of another image.

By combining her professed objectivity with the viewer's required subjectivity, nearly all Burson's images force us to reevaluate our own visual stereotypes. Where people are concerned, she asks, can you really judge a book by its cover? In one photograph, Burson merges the faces of Charlie Chaplin, Buster Keaton, and W. C. Fields to see if the results would produce the face of the "perfect comedian." She ends up with a portrait of a sour-faced, seedy-looking pawnshop clerk. In another shot, she combines Sirhan Sirhan, Lee Harvey Oswald, and James Earl Ray. The resulting "ultimate assassin" looks like the kind of pleasantly bland young man you might meet in the bar car of a commuter train.

To your eyes, the face might look different—sinister and threatening, perhaps, or bemused and inviting. As Burson herself said, most of the images are Rorschach tests for the people who look at them. "No one ever agrees [on what they

look like]," she said in a recent interview. "The images elicit the same variety of responses as faces themselves. Everyone sees something different in any face."

Yet some generalizations hold true for every observer. The most conventionally beautiful people, for instance, seem to be the most average looking; nearly everyone finds the composite faces to be more attractive than their component parts. Women's features generally dominate over those of men—a conclusion that emerged most clearly in a very feminine-looking composite portrait called *Androgyny*, which combined faces of six men and six women, weighted so that each would have equal dominance in the final image. When Burson talks about these conclusions, she uses the phrasing of an experimental scientist surprised by the results. "In *Androgyny*," she said, "it was a complete surprise that female features took over. And apparently a surprise to other people too. I don't think I went into it with any preconceived notion."

At first glance, Burson's methods seem to confirm that statement—she seems a mere technician playing out decisions that are preordained by the structure of the experiment. When I visited, Burson re-created the process by which she created two recent composites, mergers of Maria Shriver with her husband Arnold Schwarzenegger. *Picture Week* magazine had asked to see what their offspring—male and female—might look like. Starting with a full-face image of each, Burson had the computer stretch Shriver's face so her features would map onto Schwarzenegger's—eyes to eyes, nose to nose, mouth to mouth. Then Schwarzenegger's portrait was reshaped to fit Shriver's facial proportions. Burson then combined those preliminary composites into two final images, one weighted toward each gender. (Most of the time there is only one final image.) Finally, in what Burson calls the cleanup process, she adjusted the results.

"Cleanup prevents any single face from dominating the picture too much," she said. "First I make preliminary images—warping one face to fit a second, so the second is dominant. Then I warp the second onto the first, so the first is domi-

nant. Then, in cleanup, they keep getting closer, until I have a true average." Even Burson's name for this last stage—"cleanup"—downplays her own role in designing the final pictures.

But on second glance it's clear that the power of these images comes not from the computer's dispassionate manipulation of statistics but from Burson's personal vision—whether conscious or unconscious. She does far more than design the parameters of the experiment. She chooses which particular photographs to blend. She blends them, much as an oil painter would blend colors. And in cleanup she makes each composite image take on its meaning.

The Three Races provides a good example. It combines the portraits of three anonymous men: an Oriental, a Caucasian, and a black. Under Burson's direction the computer system gave them equal weighting in dominance, and the result looks like a racially mixed person. But the eyes—the features that dominate any portrait—are Oriental, and at first glance the picture seems Oriental. Is that because, on some empirical level, Oriental features represent the average of the human race, or is it the result of the sensibility that chose the representatives of each race, matched the photographs, and selected which features to emphasize or ignore for each?

Consider the most disturbing image in the book—one that might have emerged from our collective unconscious. For a CBS-network special on 1984 and totalitarianism, Burson combined portraits of Stalin, Mussolini, Mao, Hitler, and Khomeini, all weighted equally. The resulting broad, somber face—intended as a portrait of Big Brother—looks eerily similar to images of Orwell's Big Brother from at least one dust jacket of the book *1984* and from the film *1984* made by Michael Anderson in 1956. Did those images find their way subconsciously into Burson's choices, or did the earlier artists base their Big Brothers on Stalin and Hitler (whose thick hair and moustaches seem to dominate the composite)? Is it all coincidence, or is this the face of evil?

These ambiguities break through despite Burson's restraint. But the less

moving images—like the five recent presidents in *Presidents* or the merger of Washington, Lincoln, Jefferson, and Hamilton in *Making Money*—make you wish she would give herself freer rein. It would be more interesting to see composites of faces of people who are *not* icons of the mass culture but rather happen to have faces that resonate against each other. More interesting still would be to make Burson's metaphorical camera—the program that generates composites—available to the rest of us. Unlike other new media technologies, this type of photograph manipulation will probably become cheap enough in the next decade to reach the general public, like a high-tech Etch A Sketch.

You can imagine the spiel of a barker at a Composite Booth in an amusement park: "You, young couple! Want to see how your children would look?" Most of those pictures would, no doubt, be unmemorable. But, just as certainly, some wizard of composite making is lurking undiscovered out in the world, waiting to take the right faces and meld them just the right way into faces that never did

exist except in the hypothetical. Likely as not, those faces will eventually be animated on film or video. Hypothetical people, who never existed in the flesh but are composites of different citizens' features and voices, will dance across our screens.

Burson herself has taken the technique in a different direction. She still creates composites on request for clients—including parents of missing children, who want images of what their children will most likely look like after several years. But her more recent work, to be made public later this season, consists of composites of photographs of other artists' paintings, from classical to postmodern. As if to make up for the restraints on her earlier work with faces, the purpose of this new series is to deliberately apply Burson's particular point of view to images originally created by others. "When we combine the images of two paintings together, and stretch them to fit each other," Burson said, "nothing remains in its original proportion. The images are biased to reflect the meaning that I want them to reflect."

PHOTOGRAPHY IN THE THIRD DIMENSION
by Laurance Wieder

In high school, I used to amuse myself while the teacher droned by holding my index fingers about twelve inches in front of my nose, with the tips touching. By gazing straight ahead past my fingers, a third, double-tipped finger appeared between the two; when I slightly separated the tips, the third finger floated there in the middle distance. The brain's ability to synthesize a third image from two adjacent images is the basis of stereoscopic vision, of perspective. The same trick that whiled away high school can be used to view stereo photographs with the naked eye.

Kenneth Snelson's sculptures, panoramas, and stereo photographs explore the structure of space. For him, as for a distinct tradition of artists that began in the Renaissance and peaked in the 1930s, art and its materials provide a means to investigate and unravel physical as well as spiritual reality. These artists' findings have the same dignity and authority as

Kenneth Snelson, *Pont du Carrousel*, Paris, 1985

the propositions and hypotheses of the natural and mathematical sciences. Snelson employs a technology of stress and structure (which he discovered) to create his large tube-and-wire sculptures. His photographs, panoramas, and stereo views exist (by dint of machine) in the seam between science and art.

The panorama *Pont du Carrousel* (Paris, 1985) presents a sculpture's-eye view of both ends of the bridge, and of the Seine flowing through. For Snelson, panoramas simultaneously gratify his desire "to see, to show everything" and tease him with a riddle: "How does this improbable scene relate to the world as we're accustomed to see it?" Several customs get upset in the process: everything is seen at once; straight lines curve; unanticipated elements stray into the scene or attract notice. One of the great surprises for Snelson is the spatial associations revealed by the camera. "While a conventional camera allows for set composition, I think of the pan in the panorama as dynamic, a musical improvization." Snelson's panoramic print includes motion and accident, much as

Chinese watercolor paintings incorporate the (mis)chances of the medium into their aesthetic. And, like Chinese landscape, the panoramic photograph shows the world in what Snelson calls "an optically outrageous perspective." The technology of the camera, rather than controlling and predetermining the picture, literally and metaphorically opens up the picture to the unforeseen and the unnoticeable, if not the unseeable.

The stereo view, more often than not an amusement and curiosity, in Snelson's work becomes a moving study of the nature of space. Viewed as a planar photograph, *Mozart I* (1985) documents a Snelson sculpture on a woods-bounded lawn, with a lone tree in the foreground. In stereo, the sculpture leaps to life, organizing the clearing into a sacred grove. There the melody of artifice addresses earth, sky, and trees, becoming a crystallized, metal thought supported by and harmonizing with the mutable organic. The photograph is a snapshot of what survives.

If *Mozart I* suggests the temporal and the permanent, Snelson's *Atom* (May 19,

1985) concerns what physics regards as the unseeable, immaterial yet abiding. As Snelson's sculptures penetrated ever farther into the air, he became obsessed with the problem of constructing a material model for the atom as described by quantum physics. The success of that search, and its subsequent failure to find scientific backing, are another tale. This photograph of one of the artist's models declares the power of his idea to structure no-space and no-where. The black background of the flat photo becomes, in stereo, an abyss ordered by the germ of creation. Here, in the guise of an artist's quirk, is a gloss on the divine image.

A more playful take on the human urge to be, if not a god, then a giant, is offered by the hyperstereo *From the Roof, Sullivan Street, New York City* (May 12, 1985). This view of the World Trade Center towers from atop the building that houses Snelson's studio was made by placing the two lenses recording the scene approximately eight feet apart. This technique, commonly used to increase depth of field for long views, incidentally reduces the scale of objects in the picture.

Kenneth Snelson, *Still Life*, 1985

The real city looks like a model; the viewer becomes a giant Gulliver surveying downtown Lilliput.

Still Life (July 17, 1985), a complicated temporal and spatial survey, assembles objects from Snelson's past, present, and future and arranges them tellingly. In the foreground, four atom models sit on a mirror, placed on a worn Oriental rug. A square-format photograph (one half of a stereo still life) is propped so that the base of the print meets the back edge of the mirror. The print is held upright by a pair of skulls, arranged so that they peek out from behind the print. Print and skulls are partially reflected in the mirror. The foreground of the print contains a stereo viewer with a stereo print of a Snelson sculpture mounted in place; another view lies to the left. To the right are old photographs of Snelson's family, photographic equipment, and a ball used for early atom models. Rear and center, reading from the left and flanked by potted fern and cactus, stand: a photograph of the artist leaning against the doorframe of his studio in daylight, a ma-

quette sculpture, and a skull. Because the large print is not perpendicular to the mirror, the stereo view creates a phantom plane that extends toward the viewer, a tray of ghostly dainties served by the very faculty that makes us think of stereoscopic sight as real.

Between the view that life is an illusion and the view that only the material and quantifiable is real spins the lived-in world. To see that old world as fresh again, and to mock the very novelty of means, subverts finality and lends perspective to the skull (the only certainty). Uncertainty may generate anxiety, and "uncertainty" is the name of a principle in physics. As an intellectual position, uncertainty may be the only honesty, the only proper answer to pose and bombast. Snelson's pictures, both unsettling and amusing, have the strength of character to resist received ideas about the way knowledge is ordered and the way truth is revealed. In subverting the authority of the very technology he employs, Snelson manages even to undermine that plain notion: the still photograph.

IN TIME:
Earthworks, Photodocuments, and Robert Smithson's Buried Shed
by Ron Horning

In the late 1960s and early 1970s, earth art contributed to the erosion of the popular distinction between photographs and works of art by bringing photographs into previously inaccessible galleries and museums, where an audience ready for almost anything scrutinized them as if they were paintings or sculptures, drawings or prints. For artists such as Robert Smithson, Michael Heizer, Richard Serra, Walter de Maria, and Dennis Oppenheim, photodocumentation was the easiest way to get works far from the beaten art track before the small public that responded to them passionately. For, just as the artists depended completely on the mechanics of the museum and gallery maintenance system they were questioning, so too was their rebellion against the limitations of the system—physical, political, economic, and intellectual—appreciated most by the system's adepts.

Most photodocumentation—a term chosen to stress the secondary nature of the grainy gray squares of information and to distinguish the work from mere photography—was deadpan, flat, and downright ugly, a look that reflected the revolt of the artists, who were often the documenters as well, against the status of artworks as privileged commodities available to all whose checks don't bounce. The art audience, however, turned out to be ready for anything except the extinction of its own convenience and pleasure. Other, less tendentious works of art were available, and as long as one was going to look at photographs, where were the good ones? It is no coincidence that the photography boom of the mid-1970s took off at about the same time that interest in earth art lost its momentum.

Even so, earthworks, the better ones, have proved to be stubbornly vital, refusing to fade into the background like body art, environmental art, process art, and other arts of the period. But they were made to be memorable. How, after all, does one forget a jetty 1,500 feet long that spirals into the pink water of the northern Great Salt Lake from the shore at one end, steadily losing any illusion of practical value, and out of the water at the other end, a mocking parody of the sacred bellybutton on Delos? How does one forget a field of tall and gleaming steel rods, measuring one mile by one kilometer, where heat lightning snaps and sparks and flashes in an endlessly variable display of electric chance? Or a trench 120 feet long, 18 feet wide, and a foot deep at the center, where it loops out, comes back, crosses itself, and continues along its original trajectory, adding to nature and taking away with ruthless authority. These are key images of recent American art—and, for most, they are photographic images.

If the dialectic between site and artwork is strong enough, the photodocumentation of a work can be its most enduring feature, and not because the photographs reduce or overshadow the work but because they replace it with a collaboration that is better than nothing, which is what one has of *Spiral Jetty*, for example, if one is not at Rozel Point in Utah. Photodocuments of earthworks are

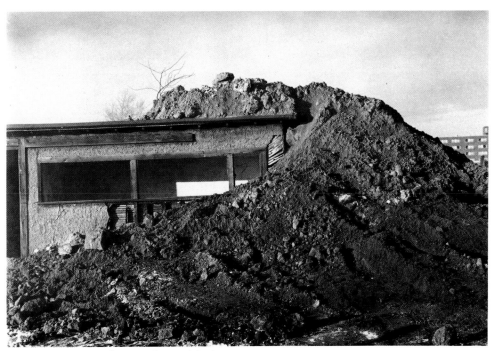

Anonymous, *Partially Buried Woodshed*, 1970

more closely related to postcards from Karnak than to reproductions of *Guernica*. Furthermore, the record of an earthwork's development is a simultaneous history of the work as object and as photographic subject that may outlast the work. Robert Smithson's *Partially Buried Woodshed* in Kent, Ohio, the second of six or seven large earthworks he completed before dying in a private-airplane crash in 1973, when he was 35 years old, provides an excellent case study in this kind of binomial history.

To take the most obvious changes first: When Smithson buried one end of the old farm outbuilding on the Kent State University campus in January 1970, piling 20 backhoe loads of raw dirt up to the wooden roof and then over it until the central ceiling beam cracked, the shed, which Kent State groundsmen had used to store firewood and gravel, was 45 feet long, 18 feet wide, and 10 feet high, with three plaster-and-lath walls on the partially buried side and two wooden walls on the open side. All that's left now is part of the crumbling cement foundation that supported the plaster and lath, and a tumulus like grassy knoll covered with bushes and young trees, which, like the rest of the discreetly segregated hilltop, conceals a dialogue with nature that has been fierce and literally consuming. Even

the work's name has been whittled down, at least in the vicinity. With an accurate economy, northeast Ohioans call Smithson's piece the buried shed.

That *Partially Buried Woodshed* exists at all is due to a fluke of the weather. Invited to Kent State to participate in a student-funded arts festival whose other guests included John Ashbery, Morton Subotnick, and John Vaccaro, Smithson decided to cap his week with a large mudslide analogous to his recently completed *Asphalt Rundown* in Rome, *Concrete Pour* in Chicago, and *Glue Pour* in Vancouver. In a speech he made after a photo-slide presentation, he justified the ephemeral nature of such works by comparing their fates to those of paintings in art galleries: "The duration of an art show in New York is three weeks, then what happens to the art?" But the ground froze up, making a mudslide impossible. For a while it seemed that instead of an earthwork there would be nothing, but the students who had sponsored his visit persuaded Smithson to make another work he had talked about, one rather more permanent than a mudslide, although not unrelated conceptually.

While in Vancouver for the glue pour, Smithson had visited the Britannia Copper Mines, and the reproductions of photographs from the mine's archives

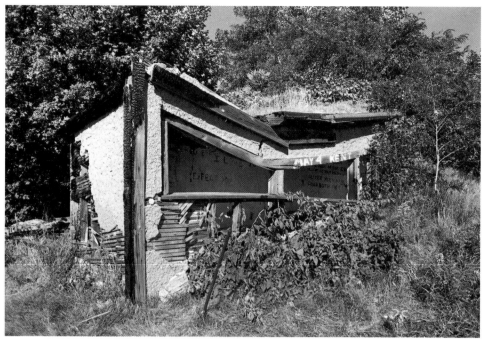

Dean Nettles, *Partially Buried Woodshed*, October, 1980

that he acquired for his files—photographs of sites he probably visited—indicate that he was especially interested in those parts of the mines rendered inoperable by flooding and cave-ins. In one photograph a partial cave-in has cracked a supporting beam with enough force to make the splintered wood look like the splayed bristles of a worn-out shaving brush. This image of collapse seems to have led Smithson to *Partially Buried Woodshed*'s governing conceit: the cracking of the central beam that signaled the end of the making of the work and the beginning of its participation in the history of the site.

Less than four months after Smithson donated the work to the university on whose land and with whose building he had made it, Kent State students demonstrated angrily against the recently announced U.S. invasion of Cambodia. Governor James Rhodes sent in the National Guard, complete with armor-piercing bullets, and one face-off took place some 700 paces from the shed. When students refused to fall back, the advancing Guardsmen opened fire. Nine students were wounded; four were killed. The photograph that hit the television screens that night and then the front pages was of a young woman, her mouth

stretched wide and black, kneeling beside a shot friend while other students scatter for cover.

The central beam had cracked again as it were, and almost immediately someone painted MAY 4 KENT 70 in bold white characters on the shed's windowsill. The connection between the shootings and Smithson's exploration of entropy would be made by many over the years. Many of the graffiti that accumulated inside the shed were devoted to May 4, and the shed became one of the campus's two shrines to the remembrance of the bloody event. The other: a bullethole, half an inch in diameter, through a plate of steel one third of an inch thick that is part of another university-sponsored work of art, a large abstract/cubist sculpture of two figures, by Don Drumm, that stands in front of the building that houses the university's art department.

Smithson kept tabs on the shed from his loft in New York. A few months after the shootings, someone stole the firewood the artist had left in the shed as part of the work. A friend in Kent sent him slides, dated November 1970, of the shed as it looked that fall, and Smithson noted on the envelope in which he kept the slides: "They took the wood and left some words."

Not long after Smithson died while surveying the site for *Amarillo Ramp*, Kent State announced plans to landscape the grounds around the shed. This part of the campus would be much more visible and accessible than in the past, and those administrators who considered the shed an eyesore if not a fraud were horrified by the thought that it would now decorate the intersection of two of the campus's main thoroughfares. Tear the shed down, they said. Leave it up, answered the work's defenders, who enlisted help from all over the art world.

The stalemate persisted until the spring of 1975. On March 28, less than a month before the U.S.'s ignominious exit from Vietnam, someone set fire to the shed, perhaps accidentally, perhaps not, but in any case damaging the left side badly. On May 3 Smithson's widow, artist Nancy Holt, went to Kent to inspect the work, which she had never seen before, and on the fifth anniversary of the shootings she wrote a letter to university president Glenn Olds, apprising him of the work's importance and suggesting that steps be taken to preserve what was left.

The various forms of pressure worked. Olds decided to let the work stand, and the landscaping in the immediate area was limited to a circle of evergreens that screened the shed from sight. An odd thing was happening: the work began to take on the appearance of an architectural folly, a Romantic ruin, a sacred grove. While this development in no way violated the artist's intentions, at least some credit for *Partially Buried Woodshed*'s changing appearance was due to a university whose actions were determined by its embarrassment at being saddled with a disturbing work of art that could not be rolled up like a painting or hidden in a basement like a gallery-size sculpture.

In 1980 the shed's central beam buckled dramatically, cinching the wide window into a sinking black stare reminiscent of Smithson's cavernous squint in the close-up by Gianfranco Gorgoni on the cover of *The Writings of Robert Smithson*, published by New York University Press the year before. People still went inside to drink beer, smoke dope, write messages on the walls, and feel the place out, but now the shed really was the hazard some of its enemies had

Chris Felver, *Partially Buried Woodshed*, 1985

claimed it to be from the beginning, and by September 1984 the university had torn the building down to its foundation. A necklace of old plaster fragments, held together by the plaster's twisted-wire reinforcement, hung from a tree branch like a votive offering. The small-bore pipe, black as a burnt match, that leaned over crazily in front of the shed leaned over still, and out in the foliage that had been behind the shed lurked the much newer metal stanchion, also bent, from which dangled a short section of steel chain. Near the bramblebushes that sprang up where the left half of the shed burned down, ground squirrels had dug out a main entance to a network of tunnels that probably angled into the mound. Birds sang and scrambled in the leaves.

For the most part, *Partially Buried Woodshed*'s changes have gone unseen, but not because the work has been neglected by the art press. Most of the May 1978 issue of *Arts* was devoted to Smithson, and on the cover was a photograph by Smithson of the shed after he completed the work. Fair enough. Inside, however, is an article about the shed by poet Alex Gildzen, who lives in Kent and works at the university. Gildzen's text, a series of diary entries from 1970 to 1978,

is accompanied by a drawing and four photographs, all from 1970—a visual hegemony that misrepresents both poet and artist. In his catalogue of Smithson's sculptures published by Cornell University Press in 1981, Robert Hobbs demonstrates a greater sensitivity to the implications of the work by reproducing two color photographs made in 1978 by Nancy Holt, along with one color photograph and several black-and-white shots made by Smithson in 1970.

But the single best visual record of the work is in the back issues of the Kent State daily student newspaper, where photos by Doug Moore, Len Henzel, Florence York, Tom Difloure, Tom Halfhill, Dean Nettles, and others illustrate the long series of articles the shed has generated over the years. The stories themselves make up a pertinent and unique body of information about Smithson's life, work, and posthumous reputation. "Breakability fascinates Smithson," read the banner over a report of the artist's slide presentation at the arts festival; "Earth artwork 'questions everything,' says widow," proclaimed the newspaper during Nancy Holt's critical visit in 1975.

If *Partially Buried Woodshed* questions

anything, it questions the idea that a work of art is frozen in time at the moment of completion. So do many other earthworks scattered around the world like unsolved puzzles. The puzzle varies from artist to artist, from work to work. The photographs that exist tell part of the story; those that do not might tell more. In *Partially Buried Woodshed* Robert Smithson replaced the fiction of permanence with the fiction of change, and his story appears to be drawing to another climax. According to the director of Kent State's office of facilities planning and design, the parcel of land on which the shed is located may become the site of a baseball field and stadium dedicated to the memory of catcher Thurman Munson, the Kent State alumnus and captain of the New York Yankees who died in 1979—like Smithson, in a private-airplane crash. If the plan for the baseball complex goes through, the shed's hill could be flattened. Except for the photographs, which now include a lyrical series begun in 1985 by Chris Felver, nothing would be left of Smithson's ingenious effort to dispel the boredom of eternity.

CONTRIBUTORS

LEWIS BALTZ has spent the past ten years documenting the urbanization of the American landscape. He graduated from the San Francisco Art Institute in 1969. His previous exhibitions include *Industrial Parks* (1974), *Nevada* (1978), and *Park City* (1980). *San Quentin Point* was published by Aperture in 1986.

DAN CAMERON is an associate editor of *Arts* magazine, where his writings appear frequently. He is also a musician whose first record was released last fall on the S.O.F. label.

LYNNE COHEN teaches photography at the University of Canada and lives in Ottawa, Ontario.

ROBERT CUMMING lives and works in West Suffield, Connecticut. A retrospective of his painting, drawing, sculpture, and photography appeared at the Whitney Museum of American Art in 1986. He is represented by Castelli Graphics, New York.

WILLIAM EWING received an M.A. in sociology and anthropology from McGill University in 1967. In 1970 Ewing founded Optica Gallery in Montreal, Canada's first commercial photography gallery, which he directed until 1974 when he became curator of the Institute of Contemporary Photography in New York. He is now the curator of special exhibits at the Institute of Contemporary Photography and has just written a complete history of the photographer George Hoyningen-Heuné, which was published in October 1986 by Thames and Hudson.

DANIEL FAUST is represented by the American Fine Arts Company in New York City, where he recently had a solo exhibition. His work was shown at the Queens Museum in an exhibition entitled *Television's Impact on Contemporary Art*. His previous body of work, "Natural History," comprised photographs of New York City. His current work, "Science and Technology," features photographs from the United States, Europe and Asia. Faust is presently preparing a book on this work.

DAVID T. HANSON is a native of Montana, where he photographed strip-mined coal fields from 1982 to 1985. He is preparing a book of the series *Colstrip, Montana*. Selections from this book were exhibited at the Museum of Modern Art in a 1986 show entitled *New Photography 2*. He has taught photography at the Rhode Island School of Design since 1983.

MARK HAWORTH-BOOTH, Assistant Keeper of Photographs at the Victoria and Albert Museum, London, directed an exhibition of Lewis Baltz's work, entitled *Park City and Other Projects*, in 1985.

RON HORNING lives and writes in New York City.

ART KLEINER divides his time between California, where he is a contributing editor at *The Whole Earth Review*, and New York where he teaches in the Interactive Telecommunications Program at New York University.

REAGAN LOUIE lives in Berkeley, California, and teaches photography at the San Francisco Art Institute. He will photograph more extensively in China in 1987.

MARC H. MILLER received a Ph.D. in art history from New York University in 1979. He is a contributing editor and former columnist at the *East Village Eye*. A commentator on "ART—new york," the educational video tape series, Miller is also the curator of exhibitions at the Queens Museum.

KIRA PEROV was assistant curator in video at the Long Beach Museum of Art in California. As co-managing editor of the catalog *Video: A Retrospective, Long Beach Museum of Art, 1974–1984*, she chronicled the history of the video program at the museum, and its influence on video art on the West Coast. She has exhibited her photographs, and her stills documenting the video work of artists have been published in books, magazines, and catalogs in the United States, Europe, and Japan.

CATHERINE WAGNER received an M.A. degree from San Francisco State University in 1977. She is working on a series of photographs entitled *The American Classroom*. An exhibition and catalog of this work is scheduled for September 1988. She is a professor of art and photography at Mills College in Oakland, California.

LAURANCE WIEDER, a poet, lives in Brooklyn, New York.

CREDITS

Cover photograph by René Burri courtesy of and permission from Magnum Photos. P. 2 excerpt from *The Myth of the Machine*, Vol. II: *The Pentagon of Power*, by Lewis Mumford. Published by Harcourt, Brace and Jovanovich, Inc. P. 3 photograph by August Sander, courtesy of Sander Gallery, New York. P. 4 photograph by Paul Strand, © 1971, Aperture Foundation Inc., Paul Strand Archive. P. 5 photograph by Janoslav Rossler, courtesy of Sander Gallery, New York. P. 6 photograph by Walker Evans, courtesy of Sander Gallery and the Estate of Walker Evans. P. 7 photograph by Charles Sheeler, courtesy of Gilman Paper Company, New York. P. 8 photograph by Fred G. Korth, courtesy of Prakapas Gallery, New York. P. 9 photograph by Edward Steichen, reprinted with the permission of Joanna T. Steichen. P. 10-11 photograph by Peter Keetman, courtesy of Sander Gallery, New York. P. 13-16 photographs by Lewis Baltz, courtesy of Castelli Graphics, New York. P. 18-23 photographs by Catherine Wagner, courtesy of Canadian Centre for Architecture and Fraenkel Gallery, S.F. P. 25-31 photographs by Lynne Cohen, courtesy of the artist. P. 33-37 photographs by Daniel Faust, courtesy of the American Fine Arts Company, New York. P. 39-45 photographs by Reagan Louie, courtesy of the artist. P. 46-51 photographs by David T. Hanson, courtesy of the artist. P. 52-57 photographs by Robert Cumming, courtesy of Castelli Graphics, New York. P. 58-63 photographs by Kira Perov, taken from videos by Bill Viola, Nam June Paik, Doug Hall, Max Almy, Ros Baron, Joan Jonas, Cecilia Condit, and Ed Emshwiller. P. 64 photograph by Nam June Paik, courtesy of Holly Solomon Gallery. P. 65 photograph by Lewis Stein, courtesy Postmaster's Gallery. P. 66 source photograph courtesy of Diane Brown Gallery, photograph by Paul Berger from *Seattle Subtext*, published by Visual Studies Workshop Press, 1984. P. 67 photograph by Thomas F. Barrow, courtesy of the artist. P. 68 photograph by Allan McCollum, courtesy of the artist. P. 69-70 photographs by Nancy Burson, from *Composites*, published by Beech Tree Books, 1986. P. 72-74 photographs by Kenneth Snelson, courtesy of the artist. P. 75 photograph by Dean Nettles, courtesy of the artist. P. 76 photograph courtesy John Weber Gallery. P. 77 photograph by Chris Felver, courtesy of the artist.

BURDEN GALLERY

TECHNOLOGY
AND
TRANSFORMATION

APRIL 21–MAY 30, 1987

Featuring the work of over a dozen photographers including
Nancy Burson, Lynne Cohen, and Daniel Faust.

Curated by Larry Frascella and Andrew Semel.

APERTURE FOUNDATION INC.
APERTURE/BURDEN GALLERY/PAUL STRAND ARCHIVE/PHOTOGRAVURE WORKSHOP
20 EAST 23 STREET, NEW YORK, NEW YORK (212) 475-8790

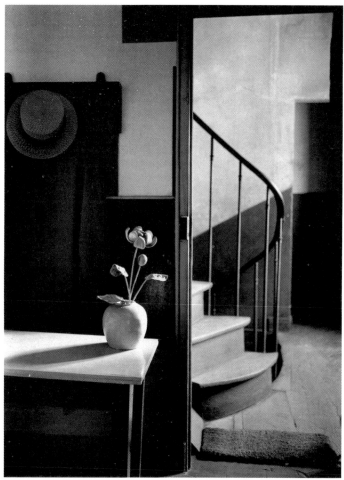

André Kertész
PHOTOGRAPHS OF GENIUS, 1912–1985

What Kertész achieved . . . has long been acknowledged to have been central in shaping the photographic style of an entire epoch.—Hilton Kramer, *Camera Arts*

APERTURE is proud to announce the first memorial publication of the life's work of André Kertész. ANDRÉ KERTÉSZ: PHOTOGRAPHS OF GENIUS, 1912–1985 is breathtaking in its facsimile reproductions. It is the most extensive presentation of this world-renowned photographer's work since he first began photographing.

Due to the extraordinary quality, the specially manufactured paper, and the superb three-color printing, the first edition is limited to 3,000 copies.

This indispensable volume is divided into four sections: Hungary, Paris, New York, and his most recent work. His earliest photographs, landscapes and studies of peasant life in Hungary, demonstrate his natural gifts and delicate sensibility. But it was in Paris that he found his greatest subject. He lovingly captured the bustling streets and cafes that were home to Picasso and the Surrealists. These photographs influenced an entire generation. In 1936, Kertész moved to New York where he lived until his death in 1985. Over four decades, he documented a world growing progressively smaller, always maintaining his personal signature and emotive force in the face of waning years. Finally he was only able to photograph inside his apartment and out of its window—and yet these photographs continue to demonstrate his boundless imagination and driving need to create.

The hardcover publication contains an illuminating essay by the critic Hal Hinson and a foreword by Cornell Capa. It is being published in conjunction with a definitive retrospective exhibition at the International Center of Photography in New York City, Sept. 11 to Oct. 31, 1987. The selection of 152 black-and-white images is based on Kertész's own evaluation of his most important work. The 14″ x 11″ book is available for $95 through Aperture or your bookseller. The subscriber discount is 10 percent.

SPECIAL OFFER TO APERTURE SUBSCRIBERS

Order by July 31, 1987, to receive *André Kertész: Photographs of Genius, 1912–1985* for the special subscriber price of $75. (Please add $4.00 for postage and handling. New York State residents add applicable tax.) Due to the limited printing, Aperture will be able to fill orders only as long as copies are available.